Hollington
Industrial Design

Hugh Aldersey-Williams
Geoff Hollington

An ADT DesignFile

First published in 1990 by
Architecture Design and Technology Press
128 Long Acre London WC2E 9AN
A Division of Longman Group UK Limited

British Library Cataloguing in Publication Data
A CIP catalogue record for this book is available
from the British Library

ISBN 1 85454 363 6

Typeset in Adobe Univers 45 and 75,
8/12 and 9/13 point.

Designed by Sushma Patel, Jonathan
Moberly and Geoff Hollington.

Reproduced, printed and bound in Hong
Kong on 128 gsm Kankazi Matt Art paper.

Contents

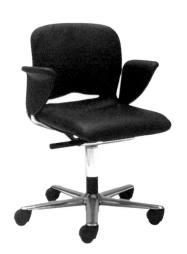

Hollington workchair 1989

Moulded plywood chair
Charles Eames 1946

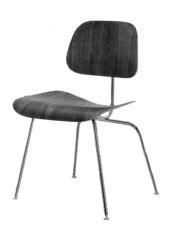

Technology and Tradition
Hugh Aldersey-Williams

The naming of chairs is a difficult matter. Like the cat in T.S. Eliot's poem, a chair must have three different names. They reveal how a new design comes about.

The first is a chair's ordinary, everyday name. The chair that marks his arrival in the major league of designers and that he spent five years and three million dollars of the Herman Miller company's money developing, Geoff Hollington called 'Theo'. This name was used throughout the design process as Hollington worked out the detail of the ergonomic adjustment mechanism, smoothed over that mechanism in order that the chair appear friendly, judged the hint of the chair's technological content that he could not resist leaving, and adjusted the subtleties of form as the feet fared out into streamlined castors and the colour and texture of the finishes and upholstery.

Then there is the ineffable name that only the chair knows – the spirit of its design. The chair is regarded by many designers as the perfect medium for the expression of their abilities; not the largest or grandest but the most demanding. Some composers feel the same way about the string quartet. '*Chair*, like *car, house, dog, tree*', Hollington wrote in his presentation to Herman Miller, 'is one of those groups of objects for which we carry in our minds a simplified, iconographic symbol to represent all members of that group, however those members might in reality differ in visual form. Small children will always draw their personal symbol for a chair, car and so on whenever required to represent one of those things; even if they intend to refer to a specific example.'

This chair brings together much that has concerned Hollington in a decade of independent practice. It is no accident, he observed, that we had come to refer to office *seating*, a commodity, rather than to *chairs*. This chair is ergonomic, but it allows for non-ergonomic uses. It tries to meet our emotional and cultural demands by being more like a piece of furniture than an item of office equipment.

Finally, there is the chair's proper name. Launching 'Theo' in 1989, Herman Miller dubbed it the 'Hollington' Chair. A designer's name became a trademark. This action

begs many questions about the role of the designer. Hollington is concerned that by naming and presenting the chair as it has, Herman Miller may unwittingly have trivialized the design, forcing it to be considered as a classic before its time. With forgivable immodesty, he adds that he would not surrender the honour now. And it is an honour. In the history of Herman Miller, the action of naming a chair for its designer has a particular resonance. Through the 1960s and 1970s, the company's pioneering office systems and chairs by Robert Propst, Bill Stumpf and others rarely became known by the names of their designers. The chairs designed in the 1940s and 1950s by Charles and Ray Eames did. There could be no harder act for a designer to follow.

Geoff always knew he was going to be a designer. The only question was what sort. Had he ever run away from home it would have been to Detroit to be a car stylist. But when the time came, he had grown to see the appeal of a more disciplined training. London's Central School had one of the more rigorous industrial design departments, so Hollington was surprised and, having done his art A level, less than thrilled to be confronted with a year of fine art. He was ready to start designing things. Or so he thought. In fact, the art foundation was to prove influential. The industrial design programme, on the other hand, was a disappointment. Far from confirming a childhood wish to be a designer, it introduced doubt and suspicion at a time when students generally were suspicious of industry. Hollington avoided the stifling course work, only working up a product design if it could be 'purified' as a minimalist work of art.

This unsatisfying period suggested a change of direction more than qualification for the real world. After graduation from Central in 1971, Hollington turned to environmental design at the Royal College of Art. In collaboration with interior designer Ben Kelly and later also with ceramicist Robin Levien, Hollington was always the one who drew the ideas, and knew if and how they could be constructed. Central practicality united with Royal College cerebrality.

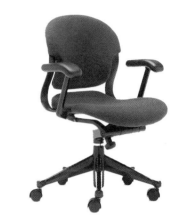

Equa workchair
Bill Stumpf and Don Chadwick

Car sketch 1966

'A' Ware 1976

Hollington's experience at these two schools set the scene for a conflict that would run through his career as he oscillated between industrial design and environmental design and back again. Today, Hollington plays down the importance of the latter in favour of the former, but it is the combination of the two that makes his design what it is. In effect, this training was something like that of the Italian designer who ultimately may call himself *architetto* and feels equipped to design almost anything. But there is more schizophrenia and less harmony in Hollington's amalgam of design disciplines, the residue of the belief in Britain that you *cannot* do it all.

The art of the 1960s is also important, especially to Hollington's product design. One work in particular stands out. John McCracken's 'There's no reason not to' of 1967 appears simply to be a large board propped against a gallery wall. What attracted Hollington was the care with which it was finished. It was utterly smooth. Its edges were perfectly radiused. It had many of the qualities of a plastic product, and yet it had much more. Its proportions were sublime, and then there was the colour. Different versions were lime green or pale blue – not really the right colours for a piece of minimal art, certainly not for a serious industrial product, and yet … why not?

After the RCA, Hollington came down to earth to work for the Milton Keynes Development Corporation under the architect Michael Glickman. Their responsibility was for the spaces in between the buildings that were being erected. Owing to the vast scale of the endeavour, it was sometimes possible to get more done with less supervision than would often be the case. Budgets were not a problem. As a result, several of the designs are unexpectedly well thought out. They are objects, like giant products, but they would lose their meaning without their context.

After Milton Keynes, Hollington went into partnership with Glickman. Together they designed a number of chairs and interiors. Hollington does not remember the work of this period fondly. Where Glickman calls the chairs they designed witty,

Hollington now finds them simply ugly. Any sense of teamwork quickly deteriorated as business dried up.

It was Glickman's last gasp to broaden the remit. He had spent some time in the Eames Studio in Los Angeles and introduced Hollington not only to the American designer's furniture, but also to his innovative way of organizing films and exhibitions. Now, he saw the potential for a British company that would emulate Eames, not only designing but also handling communications, video and exhibitions. The two designers were joined by Mark Brutton, who had just left the editorship of *Design* magazine, but the venture did not succeed.

When Glickman and Hollington split, they agreed that Glickman, whose persuasive charm had brought in most of the business, would keep the clients, and Hollington would keep the premises. It was not a conscious decision that Hollington rid himself of the interiors work in this way, but these unhappy events did provide the conditions for his attention to turn once more to industrial design.

George Harvey desk 1982

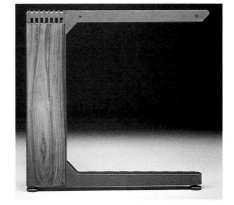

The foundation of Hollington Associates in 1980 made a break with the past. Collaboration and compromise had been tried and had failed. Hollington now wanted to be entirely responsible for each design, to take all the credit or all the blame. There was just one problem: he had no product design to speak of in his portfolio.

So the first project was more furniture – a complete office system for G.A. Harvey, then an independent British furniture company, since taken over by Gordon Russell. The job meant learning about office systems from first principles in order to design desks, storage units and screens. Hollington criticizes this work today for being too product-like. Apart from its Miesian architecture, the only sophistication was a hierarchy of texture – the details became more inviting to the touch the closer they were to the user. The project whetted Hollington's appetite to design the only item missing from the collection, an office chair.

Two seating projects soon came his way, though both took several years to come to market. The more important of the two was the Basys chair, designed for the British firm, Syba. This lithe and dramatic object has its seat cantilevered back from the knee over the chair support. This is exciting but also practical. Placing the hinging mechanism at the knee allows the controls to be found easily at the front of the chair and adjustment to be made without the feet lifting off the ground as the chair is tilted back. The same goal is achieved by different means in the 'Hollington' Chair. Visually and functionally, Basys is its precursor.

Meanwhile, in order to inject some proven industrial design expertise, Hollington had invited Nick Oakley to become his first associate. The result was the consultancy's first manufactured product, the Enterprise home computer, a product intended to be utterly different from the prevailing Sinclair style of minimal and flimsy black boxes. The idea was to articulate the difference between the keyboard at the front and the 'brains' at the back. The former was given an amorphous rounded appearance, while the latter was a hard-edged expression of technology.

Just as Hollington's varied education could be said to give him the broad background of an Italian *architetto*, so his studio loosely follows the Milanese model. There is a powerful myth about the workings of the studio of a Bellini or a Sottsass. The impression – accurate or not – is that each object is the result of the principal's personal inspiration. Hollington hankers for a similar set-up, but is not brutal enough to force it. His associates, John Choong and Jane Rawson, and other designers share the credits.

With a staff of eight, Hollington Associates remains too small to build real momentum, prey to fluctuations in workload. Growth would compromise the quality of design. Cutting back would be feasible, even with a client as large as Herman Miller, but the social interaction would be lost. As it is, Hollington can control the design process. Yet there is still the time and inclination for theoretical studies, with members

Enterprise computer 1983

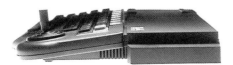

of the studio working individually but in parallel.

Hollington does not detect a signature in his objects, though he can identify one in the work of designers whom he admires such as Mario Bellini and Richard Sapper. Colleagues and clients claim they can pick a Hollington piece out of a line-up, but have difficulty saying what it is about a design that allows them to do this. It can hardly be possible to describe the elements that unite a design language that addresses everything from calculators to chairs. Nonetheless, there is frequently the union of a hard-edged platonic shape with an organic complex curve, as in the Enterprise computer. Where volumes collide, they sometimes do so at an angle a few degrees off the standard 90 or 180 degrees. This shows in the chess board for the Hong Kong client, White and Allcock, which Hollington refers to as the aircraft carrier, and in the Panasonic videophone project.

The most obvious distinguishing feature is Hollington's highly personal colour sense, an area where most designers seem ignorant or uninterested. Hollington credits the Central foundation year with instilling this sensibility and mourns the reluctance of most designers to experiment with colour as they would with form. They do not question that computers and kitchen equipment should always be white or off-white. A shift such as Apple Computer's to stone grey from the prevailing IBM beige is as much as they can take. Hollington often prefers colours that might be called off-black such as aubergine or British Racing Green.

There is a sense in which the ideas explored in this sequence of products are merely rehearsals for the main act. As these electronic gadgets were making the transition from drawing-board to production line, Hollington was already secretly at work with Herman Miller. Work had begun on the 'Hollington' Chair in 1984. Hollington has since completed the design for a revolutionary range of office furniture called 'Relay'.

Videophone 1986

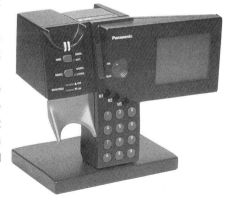

Relay folding screen 1990

Relay high performance desk 1990

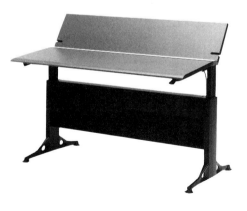

In describing how Hollington's – or any designer's – relationship with the world's most reputed office furniture company began, it is impossible to avoid the word courtship. For the first half-century of its existence, Herman Miller relied on the judgement, understanding and diplomacy of its founder, D.J. DePree, to encourage designers and nurse their designs into production. This was the patronage that brought in Gilbert Rohde and then George Nelson and Charles Eames.

The encouragement of good designers is no longer DePree's personal responsibility, but the company still believes in the power of intuition and must gauge its prospective designers' capacities for it. It is rare for designers to feel that a company's input improves their design, although this input is often vital to make a project technically feasible or affordable. It is still more unusual for a designer to acclaim such involvement. Yet Hollington is happy to do this, and even goes on record to ridicule early versions of his proposals to the company.

The key to this exercise in self-awareness is the Design Program Manager assigned to each project undertaken by an external designer. The liaison does not only encourage confessions. In Hollington's case, it gave him the confidence to trust his own intuition. At last, he could give his all to each design in the knowledge that the only constraints would be those for the best reasons – the need to meet the demands of a high-volume manufacturing process and satisfy a huge, diverse market.

Herman Miller encourages its designers to work without worrying whether such and such a part can actually be made. Technically more adept than many designers, Hollington perhaps does not gain from this as much as others, remaining too aware of potential engineering limitations. But there are instances of a shared quest for the new. For the High Performance Desk (part of the 'Relay' collection), Hollington settled upon an impossibly small mechanism for the height adjustment. Handed over to Herman Miller's Development Unit, the mechanism was duly engineered to the design

size. A stronger example of this commitment shows in the feet the desk might have had. The Development Unit wished to apply a gas-assisted injection moulding process in which a puff of nitrogen would blow nylon with chopped glass fibres into a mould to form the feet. Hollington was equally keen. After exhaustive tests, the process still fell short of requirements and cast aluminium was used.

Hollington refers to 'Relay' not as 'a kit of parts', a term beloved of British high-tech architects who admire modular construction (and who take inspiration from the Eames house), but as 'a collection of pieces'. The phrase suggests that each member of 'Relay' exists in its own right, not reliant on others. So it is surprising to learn that 'Relay' did not spring fully formed out of a re-evaluation of traditional furniture types as a reaction against systems furniture. Instead, it evolved organically from these systems. Early sketches show a number of semi-detached members of the collection – a 'tool chest' cantilevered off the side of a desk or the elegant 'dragonfly' that hovered at arm's length, as a receptacle for stationery with two diaphanous clear plastic wings for holding papers. These proposed pieces were discarded. But they make visible the evolutionary step Hollington was trying to take away from standard systems ideas.

'Relay' is not nostalgic homage to Sheraton or Shaker design, although for some people the wood finishes and pure lines do evoke these styles. Instead, as the progression of early proposals shows, it is above all a product of analytical Modernist thought, aiming to meet current and future office needs. That task fulfilled, Hollington worked hard to introduce details that would be familiar from the domestic setting. Each 'Relay' piece has a traditional forebear, yet in the context of the office, each piece looks surprisingly new and behaves in a new way. 'Relay' is Hollington's most sustained exploration yet of ideas about the object and the space around it and his most convincing synthesis of technology and tradition.

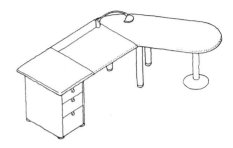

Sam I Workstation concept 1985

Sam II Workstation concept 1986

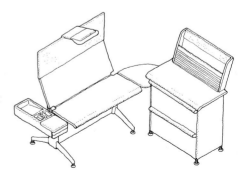

Art Student
1969–74

In 1949 England was in the early stages of post-war austerity – and I was born. But summers were sunny and winters were snowy (as I recall) in Hainault, Essex, where we lived in a tiny terraced house. Ours was not a professionally creative household. My father was a civil servant and my mother looked after me and my sister, though she was a whizz at needlework and Dad was keen on DIY.

We moved to Bromley, Kent when I was eight. I spent my free time drawing and making things: they said I was going to be a 'commercial artist'. When I was given a 1957 spotters' book of American cars – it was the best year for fins and chrome – it was like a message from another planet.

My first conscious design project was an electric guitar, started when I was thirteen. It was a triumph of form over function. I was passionately interested in cars – the way they looked – especially American cars, which I considered by far the most exciting. I subscribed to American car magazines and collected brochures. Car styling would be my career (I bought a set of ellipse guides, for drawing wheels) and enquiries indicated that I should study industrial design, at Art School. There were no auto-motive design courses back then. In 1966 I discovered *Design* magazine and it began to dawn on me that industrial design was a healthier discipline than car styling, so my appreciation slowly shifted from Detroit's Coke bottle curves to the cool white discipline of Braun *et al.*

Central was the top industrial design school, so I applied to its foundation course. I wasn't expecting to have to do a year of painting, life drawing and sculpture – foundation was all fine art at Central – but that year was the most important of my design education. It overturned all my tight little ideas about design and art. Most of my peers were going on to fine art courses, but I stuck to my plan and applied to do industrial design.

I got in, but it felt all wrong – highly vocational and unintellectual. It was 1968, the year of flower power, so white coats and machine shop practice seemed, well, uncool. I rebelled, spending little time on coursework and going my own way – closer to sculpture than design. Preoccupied with form, I would only tackle a design problem if I could get a strong abstract shape out of it. I was jealous of the sculpture students. Then Ettore Sotsass came to give a talk. I was enchanted. He was a designer but his work had the wit, spirit and intellectual dimension I sought. Ironically, through all my soul-searching, I was a closet technocrat, caring a great deal about how things worked and could be made.

Opportunities for design graduates were not good in 1971 and the Royal College looked rather glamorous. I didn't want to do three more years of industrial design, so I applied to the interiors school: I could move on, literally, to bigger things.

The school, run by Sir Hugh Casson and Margaret Casson, was delightful, but an anachronism. The teachers were heavyweight but the subject was essentially light. My year marked the beginning of a break from tradition with a move towards architecture. Some years later the school itself finished the job and became an architecture school.

Ben Kelly and I were kindred spirits from day one. We worked together on extra-curricular projects whilst somehow fitting in our coursework. We discovered Robert Venturi, and his ideas chimed precisely with our own dim intuitions.

By the time I graduated from the RCA I had evolved from would-be car stylist, to industrial designer who really wanted to be a sculptor, to interior designe 'ho really wanted to be an architect.

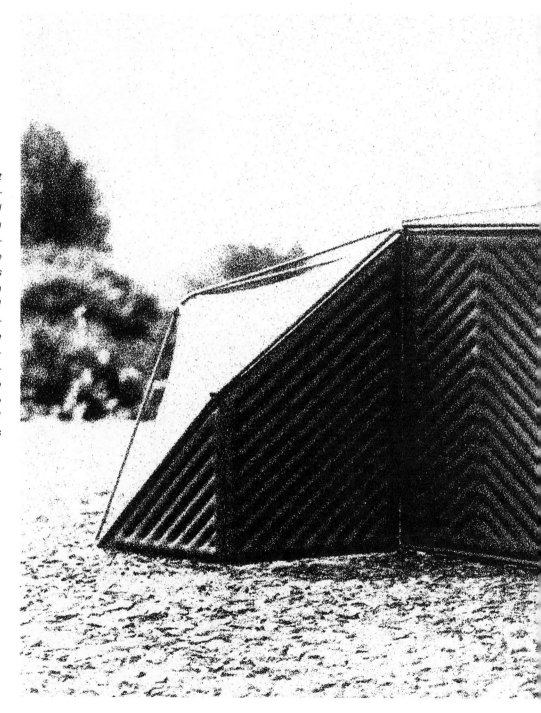

1971 Tent Structure

This was my degree project at Central. The demountable structure consists of a tubular-framed hexagonal core onto which you can attach up to five lean-to enclosure elements. One vertical core face is always the door – which is a cellular inflatable panel like an airbed, as are the other vertical claddings. Each enclosure element consists of a tubular frame supporting a tensile plastic membrane. Everything zips together – which was a little ambitious. The photograph shows a 1:10 scale model with terracotta coloured tubes, olive drab inflatable panels and clear membranes.

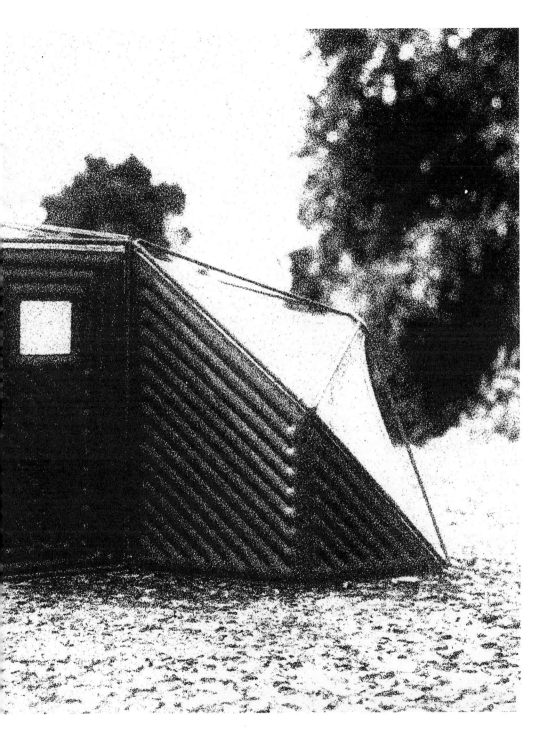

1969 Spiral Staircase

A modular spiral staircase made from steel sheet and tube. The concave treads are lined with rubber. The photograph is of a 1:10 scale model. The steps are painted purple-grey and the handrail is a pale flesh pink colour.

1970 Room Exhibit

I designed and built this installation for an exhibition named Electric Theatre that ran in the ICA Galleries, London in 1970. The hexagonal room had four mirrored, gridded walls and two black walls outlined in red light, which contained the entrance and exit doors. The ceiling was a suspended grid of back-lit triangular panels. The effect of the mirrors was to create an infinite 'landscape' populated by an infinite number of 'solid buildings' formed by reflections of the two black walls. The illuminated ceiling oscillated on and off on a thirty-second fade cycle. The 24 ceiling panels were made to exact size with no tolerance, so of course they were too big and had to be individually reconstructed throughout the night before opening.

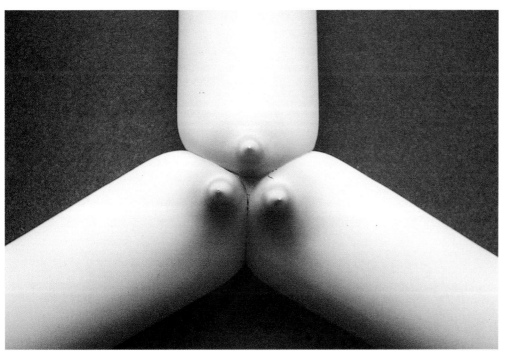

1969 Exhibition Structure

This was a demountable, travelling outdoor exhibition promoting natural gas. The strange shape was intended to suggest gas flames, as a signal to be read from a distance. There are three entrances and the graphic exhibition panels are grouped at the centre in a cave-like space. The structure would have been made from sections of glass-reinforced plastic. This design, like the amplifier of the same year, was probably influenced by Phillip King's sculpture.

1972 Chair

This glass fibre and polyurethane-upholstered dining chair was my entry for the Dunlopillo Design Award that year. It was joint student prizewinner (Jane and Charles Dillon won the main prize). The jury – which included Dieter Rams – thought it 'in the spirit of the age', but too heavy.

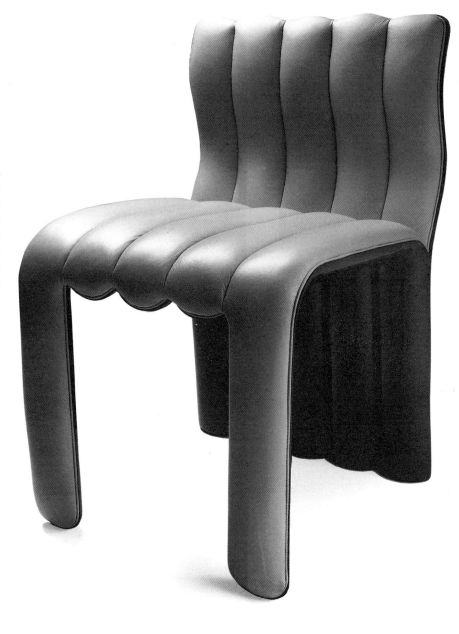

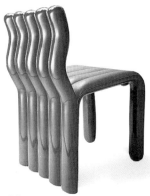

20

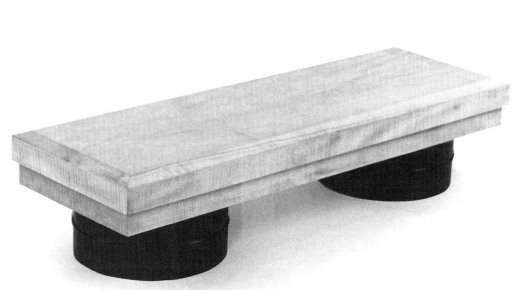

1969 Sycamore Chest

In a sense this is a found object (pace Duchamp). I had a Bakelite cigarette box, bought from Habitat, which I sat on two cylindrical tins. I was so pleased with the result that I decided to make a full-sized piece of furniture just like it. The hinged box is made from waxed sycamore (solid and veneer) and the bases are formed ply painted high-gloss dark green.

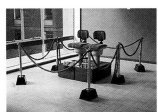

1973 Chair Art

A satirical speculation about the office chair of the future, regrettably accurate in some respects. Two identical chairs were made. Dark green marble-effect plastic laminate plinths conceal castors and the upper parts are made from pink plastic and black rubber. Fashion student Chrissie Walsh made the upholstery. Designed with Ben Kelly.

1971–84 Photographs

I started taking these 'environmental abstractions' when I was sent to Brighton for the day on an RCA crash photographic course. The sun shone, and everywhere I looked there was a 'painting' waiting to be recorded. When we had a studio crit. for the project, a tutor complained that there weren't any people (or dogs) in the pictures.

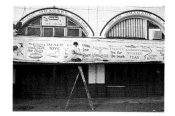

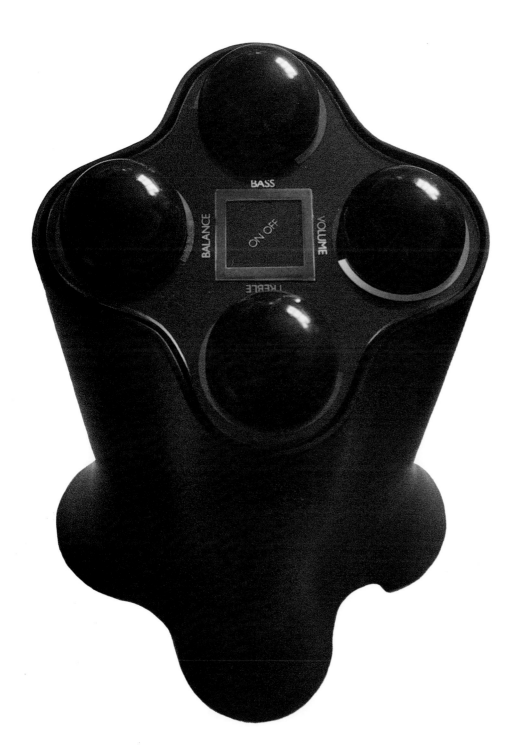

BASS
ON OFF
BALANCE
VOLUME
TREBLE

1969 Stereo Amplifier

I called this an 'expressionist' design (no one had heard of product semantics then). The idea was that the thing gathered itself up into an extruded shape and then presented the controls to you. It was for table top rather than shelf. The minimal control knobs are ringed by coloured bands of light that grow or change colour to indicate level changes – all done mechanically because LCDs were still a long way off. Sockets are on the underside, with wire access by mousehole. The body is dark brown and the knobs are dark green and glossy.

1974 Art Bar

The Art Bar was a refit of the RCA's existing student bar. The walls were painted in gloss and matt dark green. The archaic seating, upholstered in dark green PVC, and the marble-effect plastic laminate tables, came from a Midlands company called Baxmander Tubular Productions. The neon sign, fluorescent tubes and radiators were all pink. There was a continuous lakes-and-mountains photo mural applied to the bar shutter. The style is ad hoc rather than high-tech. Designed with Ben Kelly.

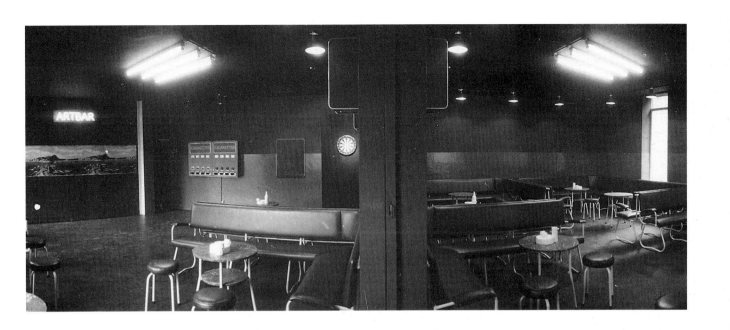

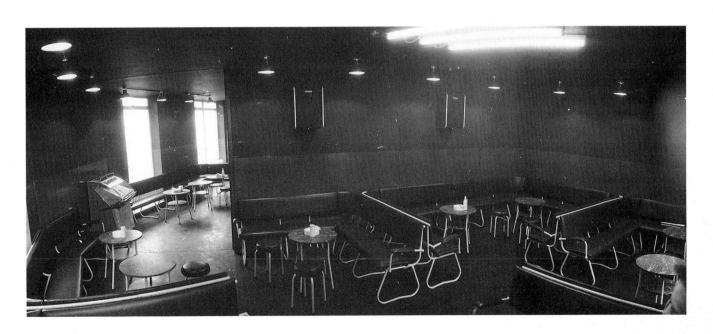

Testing Times
1974–80

For my first year in the real world I freelanced for interior design firms doing shops and showrooms, but the work was not too rewarding and I wasn't making much money. Most satisfaction came from teaching interior design one day a week at Kingston Polytechnic; Peter Lloyd Jones was building what has become a very successful design school.

I wanted a real job and someone suggested I try Milton Keynes. Development activity at the new city was at its peak and chief architect Derek Walker had assembled an impressive team of architects and designers. I was offered a job in the City Structure Group, which was responsible for street furniture and infrastructure design, under group-leader Michael Glickman. I had never met anyone like Michael before. He could certainly talk, and he had a way of approaching certain kinds of design problems – the ones that require a system-solution – that appealed to me. Our first project together at Milton Keynes was a remarkable opportunity. We were to design a seventy-metre master aerial tower, working in collaboration with Anthony Hunt, the structural engineer. The tower we designed, with its massive triangulated steelwork, mosaic-covered plinth and grass mound, nestling in the edge of a wood to the north of the city centre, was all set to be built when general manager Fred Roche threw it out. He decided that a vertical feature like the aerial didn't fit the horizontal personality of the Los Angeles-inspired city. Apart from the aerial, I designed bus shelters (including, according to Reyner Banham, the world's first Miesian rural bus shelter), sign systems, bits of landscape, and some oak benches for the giant shopping building.

While I was at Milton Keynes, Ben Kelly and I were asked by Robin Levien, a mutual friend and RCA ceramics student, to collaborate with him on his degree project. It became 'A' Ware and 'B' Ware – two ranges of ceramic products with a kind of raw, stripped-down geometry that you just didn't see back then. The three of us met about once a week and turned out one design per session working to a set of rules that we had formulated. Robin made a substantial edition of prototypes. We never succeeded in getting the stuff produced: Terence Conran thought it was interesting but...

In 1978 Michael Glickman left Milton Keynes to pursue a consultancy project and I left soon after to join him in partnership, so we could take on the work – several ranges of furniture for Pel Ltd – together. We also started on new offices for Michael's old client – Island Records. The partnership was productive and interesting at first. Michael was stimulating company – he had worked in Charles and Ray Eames' office in California in the early 1970s, designing exhibitions, and he was a great Eames enthusiast with many anecdotes about life and design in that office. And I learned a lot from him. But the relationship lost its magic (my marriage had also failed a little before, so it was a difficult period) and we wound up the business late in 1980. It was time for me to see what I could do on my own.

That's not the whole story though. In 1979, during a lean period, Michael and I decided to launch a communications design business alongside the partnership. We persuaded Mark Brutton, late of the *Design* magazine editorship, to join us, along with Gus Coral, a photographer. The firm was called Pointer Communication and the mission was very Eamesian: to bring to the problem whatever medium or media would best serve the need. Pointer in that form suffered from lack of commitment from its part-time partners but later became Mark Brutton's writing and design business.

1979 Plexus

Plexus was a whole collection of contract furniture: this is the lounge seating. The frames are made from flat-oval tube with welded joints at floor level concealed by moulded plastic caps which double as glides. Upholstery fabric and foam cushions are heat bonded together – there is no stitching – then glued to a formed ply shell. Manufactured by Pel Ltd. Designed with Michael Glickman, seen below with Geoff in 1979

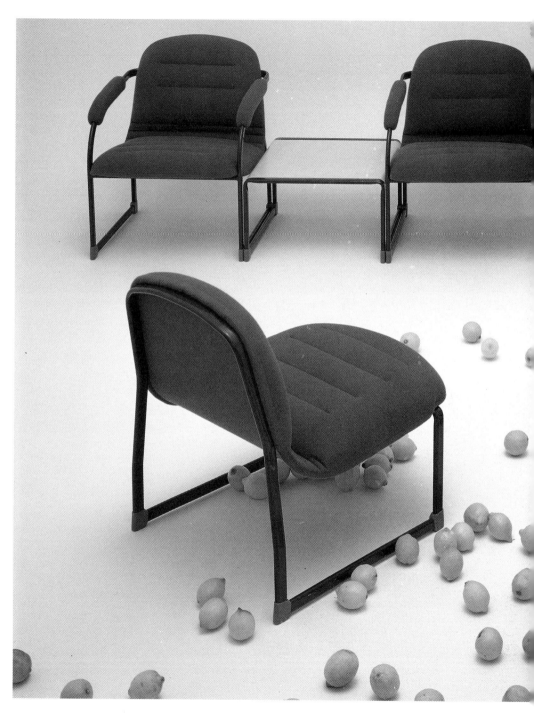

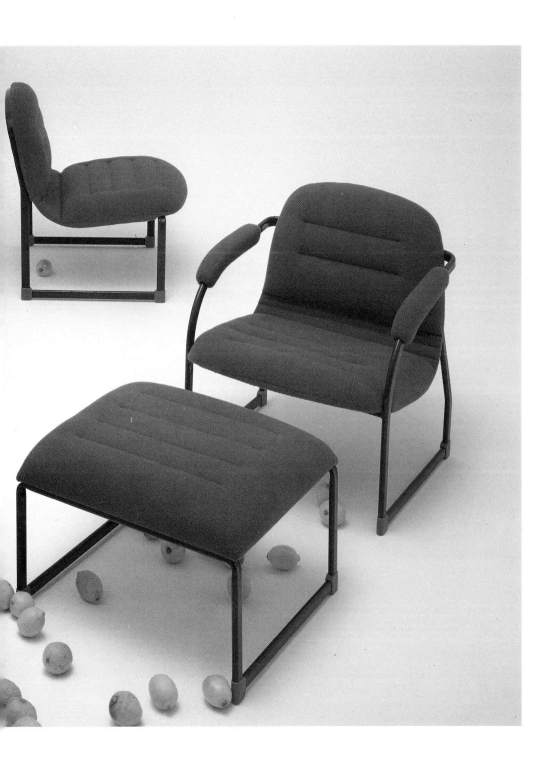

1976 'A' Ware

When Robin Levien graduated from the RCA's Ceramics School in 1976 he showed products designed in collaboration with Ben Kelly and me. This was an odd thing to do, but he got away with it. 'A' Ware was a range of giftware: vases, plant pots, mugs, candlesticks and so on, intended for volume production in white, clear-glazed slip cast earthenware. The forms are stark and geometric and the embossed logotype is always a central feature.

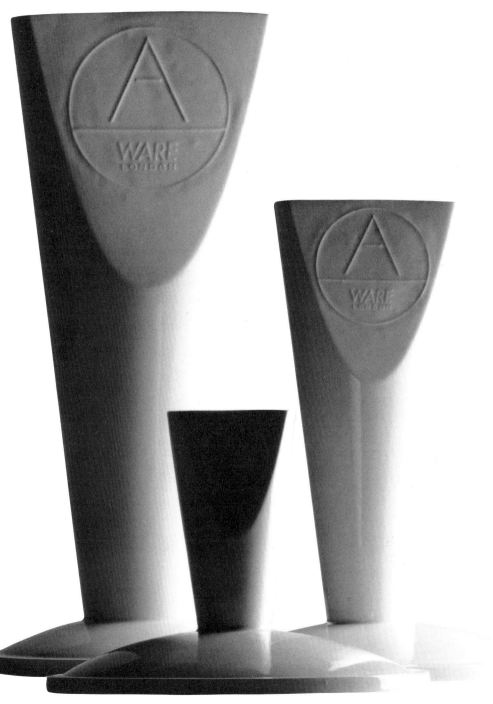

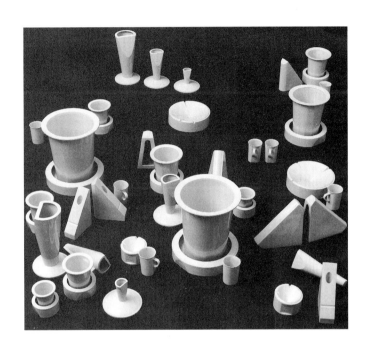

1976 'B' Ware

'B' Ware was the companion to 'A' Ware, and was designed to be produced in lower volumes. Made from pale purple-grey slip cast earthenware, each piece features a structural support element in a second material such as marble, wood or glass, has rubber feet and a gold logotype. 'A' Ware and 'B' Ware pieces each have an illogical element, which Robin called its 'existential twist'. The designs were not manufactured. Designed with Robin Levien and Ben Kelly.

33

1976 Master Aerial

Milton Keynes needed a seventy-metre-high aerial tower to receive signals to feed its cable TV network and to serve the emergency services. The design was to provide a much-needed vertical feature for the city centre. A grassed mound houses equipment and from its centre a mosaic-tiled concrete plinth emerges. Onto this are bolted seven steel mast modules. The aerial was not to be built – a crummy off-the-peg mast went up instead. Designed with Michael Glickman. Consulting engineers were Anthony Hunt Associates.

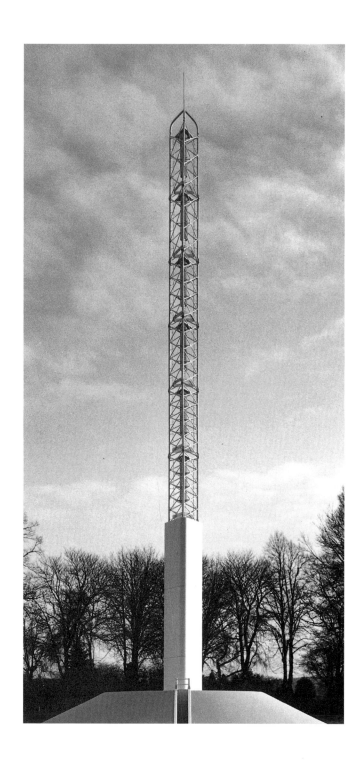

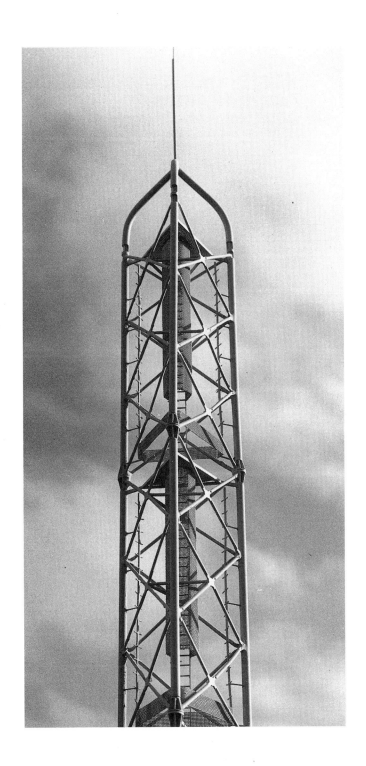

1977 Bus Shelter System

Intended for use throughout Milton Keynes, the system allowed the format of each shelter to be specified to suit its site. The main parts are an aluminium portal frame and roof (in two sizes), a glass panel, a wooden panel and a seat. Manufactured under contract.

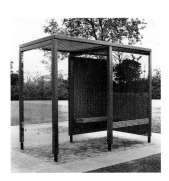

35

The Practice
1980

Hollington Associates started life in late 1980 with just me, the Belsize Lane studio (shared with Brutton's Pointer company), no design work and absolutely no credibility in industrial design – my newly chosen profession. Remarkably though, within days I was asked to design an office furniture system. Yes, it was furniture design, not product, but the work was enough to keep one person fairly busy, if not rich, for some time. That initial good fortune was not to repeat itself for a while though. I planned the early 1980s badly, starting a new business on shaky footings while attempting to recover from a failed marriage, and all with absolutely no money.

Slowly – very slowly – some sense and security emerged. I employed some good people: Beverley Andersen early on, then Nick Oakley who helped me pull in our first real product work. John Choong came later, followed by Jane Rawson; and they both stayed to become associates and help me develop the practice. In 1984 I married Liz (who had once been my secretary) and another important relationship, with Herman Miller, began in earnest that September.

The practice is still modest in size: there are just eight of us now and there is no plan for anything much larger. There are plenty of big design businesses in London. Large size may be a virtue if there are substantial interiors or corporate image contracts to execute. But I'm not so convinced of the need for corporate heft in product design – given the scale of the average project. The clients that come to us seem to be attracted by the personal scale of the consultancy and by the quality of our work; they're not looking for an 'agency' approach.

Our studio is a Victorian Gothic schoolroom under a twenty-foot high timber-trussed ceiling. There are giant stone-mullioned Gothic windows and cream-coloured brick walls. Every day I spend here I rejoice in the quality and richness of the space. I'm sure it somehow informs our work but, ironically, we do that work on CAD workstations – six of them – with not a drawing board between us. I enjoy the contrast.

Work for Herman Miller has been a substantial chunk of our activity for some time but it has never overpowered the studio because I rather jealously keep much of it to myself. It certainly keeps me busy, both in the studio and in the United States, where I go every six weeks or so. Much of our work for other clients is long term, strategic, systematic stuff and it is taking us into increasingly varied product areas. Equally important is the more visual, more subjective work – like a range of pens and pencils I'm working on now. (Some of the most interesting work is under wraps and won't go public in time for this book, unfortunately.)

My art, or craft, is still very personal – just as it was back in the early days at the Central School. I don't believe you can legislate for effective design, nor do you automatically create it with a corporate machine. There is too much, far too much, indifferent design around. We seem to have lost the ability, as a culture, to produce naturally good things so we rely entirely on the sensibilities of the thousands of individuals who shape our physical surroundings and the artifacts that fill them. Most of those individuals let us down badly, but how can we expect them to do otherwise? Why should we assume that all design professionals can necessarily be gifted artists?

Hollington Associates is only now, at the start of its second (and my fifth) decade, getting into its stride. So am I in a sense. We're both late developers. There still seems to be lot to learn, and I hope it will always be that way.

1982 George Harvey

The brief was to design a comprehensive screen and desk-based office system which could incorporate much of the client's existing range of steel storage cabinets, with some cosmetic changes. Most design effort went into the desk, which has cast aluminium end frames and honeycomb-core tops. Wire-management is fully-concealed and visually low key, with the exception of the slotted corner caps, which suggest high-tech purpose. The product was engineered at Harvey by John Fogerty, who designed some later additions to the product. Manufactured by G.A.Harvey Ltd.

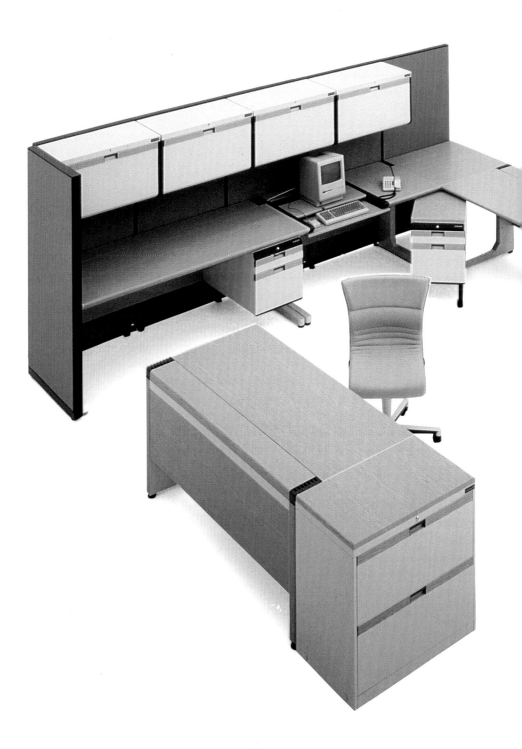

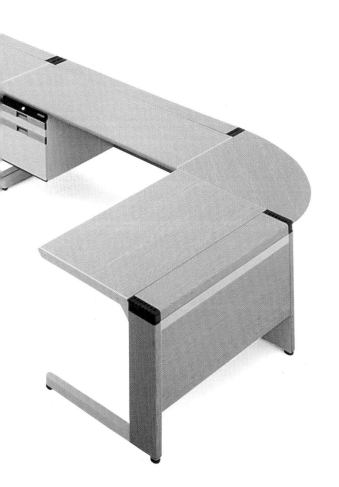

1984 Cheque-Processing Workstation

IBM Europe commissioned a prototype to test the feasibility of incorporating their modular cheque processing equipment into an ergonomic workstation. Designed with John Choong and Beverley Andersen.

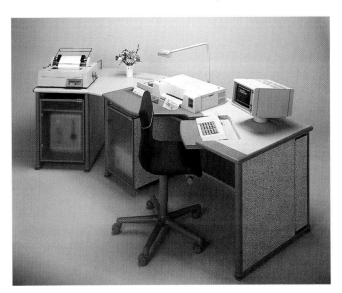

1987 Basys

Basys is an office workchair and a side chair, both with low or high back, with or without armrests. All the design, engineering and development was carried out at Hollington Associates. We wanted a chair with a thin one-piece seat and back element that was cantilevered from its support structure at a tilt point right at the front of the seat. Adjustments for tension and height had to be at opposite ends of this tilt axis. This proved quite a challenge. The production design uses a steel torsion bar spring for the tilt and aluminium castings for structure. The foam seat/back moulding conceals a steel skeleton which flexes at spring steel hinge points located at the back of the seat. The armrests are made from gas-injected glass/nylon composite. Manufactured by Syba Ltd. Designed with John Choong.

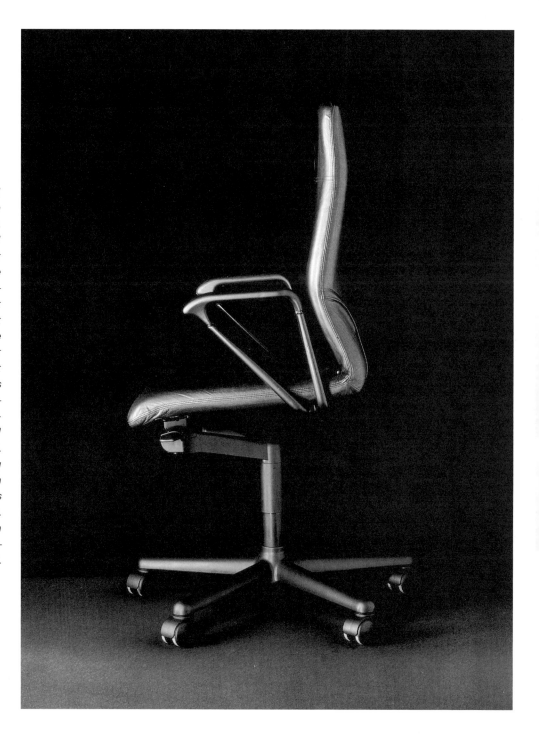

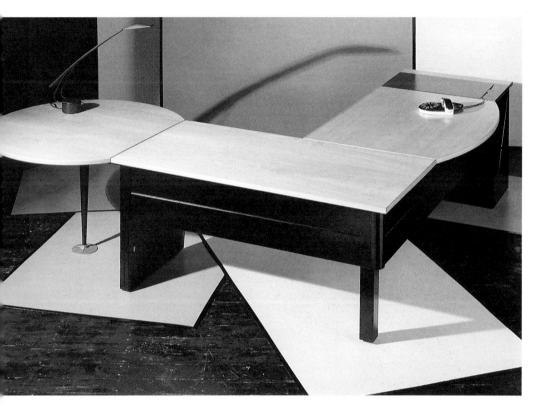

1987 Desk System

We built this prototype to test an idea for a kit-of-parts workstation-building product. The basis for each workstation is a steel drawer pedestal from which tops and wire management beams extend. Tops come in various shapes and there are several kinds of legs. Each workstation, whatever its shape and extent, reads as a single unit rather than as a collection of separate desks and linking pieces, as is usual. Designed with John Choong, Peter Pfanner and Peter Emrys-Roberts.

1984 Secta

Secta is a modular reception seating system that can be used to make individual chairs or interconnected groups of seats and tables. There is no structural frame, just formed ply seat pans and backrests, and machined wood legs, all held together by small diecast connecting brackets. Manufactured by Gordon Russell plc. Designed with Beverley Andersen.

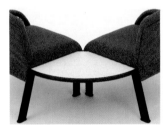

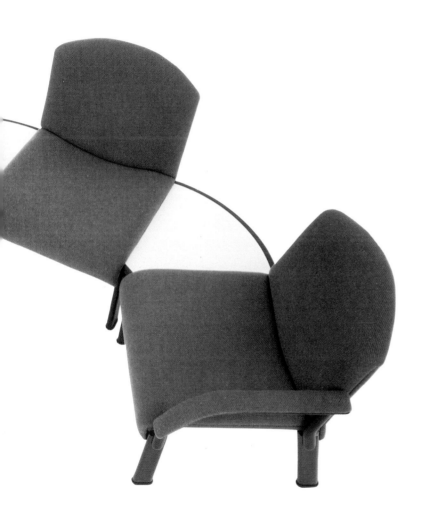

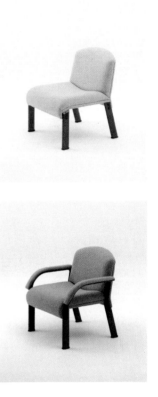

1984 RAT

The RAT was an infra-red remote 'joypad' for use with home computers. Its shape is extremely organic and its controls are derived from a single embossed, back-printed membrane switch mat. Manufactured by Park Electronics Ltd. Designed with Beverley Andersen.

1986 Pocket Chess

This little computer is the size of a calculator yet has the same chip as the bigger chess machines. The temptation would be to make it look just like a calculator, but it isn't one, so it should have its own personality. The rather rectangular geometry seemed to help it to look brainy. Manufactured by White and Allcock Ltd, Hong Kong.

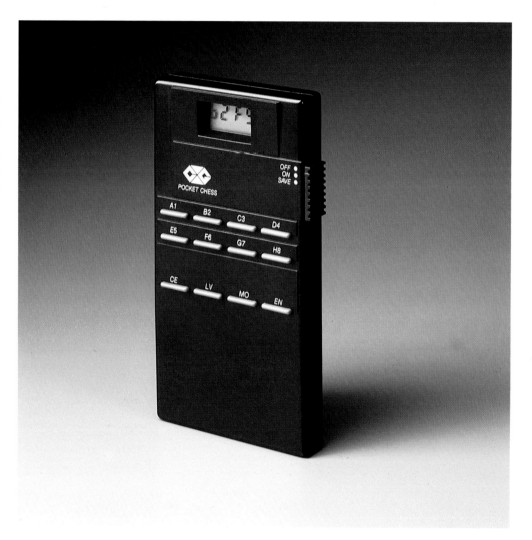

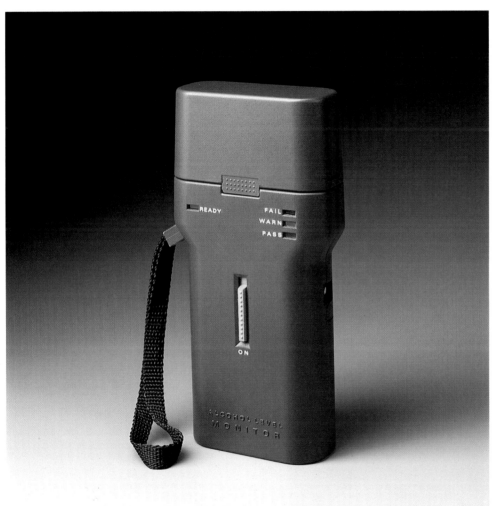

1985 Alcohol Monitor

A personal alcohol monitor for drivers. The lid contains two additional mouthpieces (for your companions). John enjoyed the hip flask shape, which is largely determined by the sensor and the large number of batteries required. Manufactured by White and Allcock Ltd, Hong Kong. Designed with John Choong.

1986 Telephone

This research project gave us the opportunity to design a new telephone product with some of the presence of the traditional rotary sort. The handset rest is moulded in frosted clear plastic and the whole instrument has legs on the underside to adjust its tilt angle, like a computer keyboard. Designed with Simon Morgan.

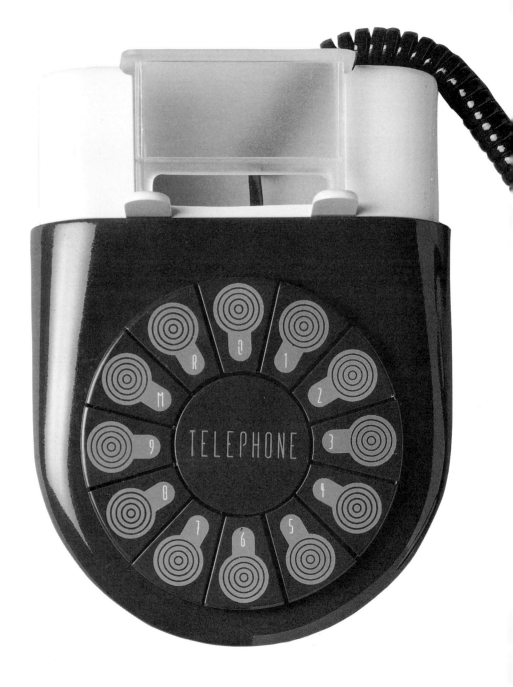

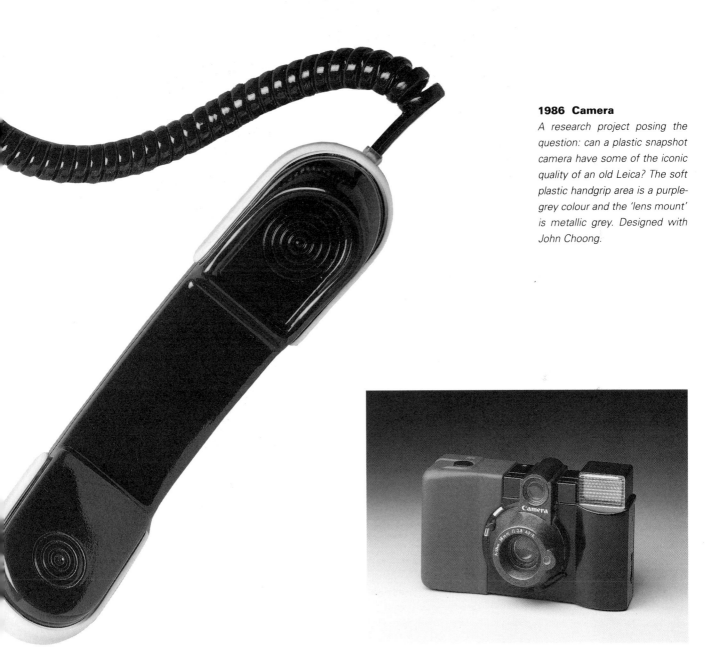

1986 Camera

A research project posing the question: can a plastic snapshot camera have some of the iconic quality of an old Leica? The soft plastic handgrip area is a purple-grey colour and the 'lens mount' is metallic grey. Designed with John Choong.

1986 Vacuum Flask

This spun metal and plastic vacuum flask was a research project. It has an integral spout and a small tan leather loop around the neck which is more for decoration than utility. The metal body has a copper-coloured hammer-finish coating, the neck moulding is black and the spout and cap are grey. Designed with Jane Rawson.

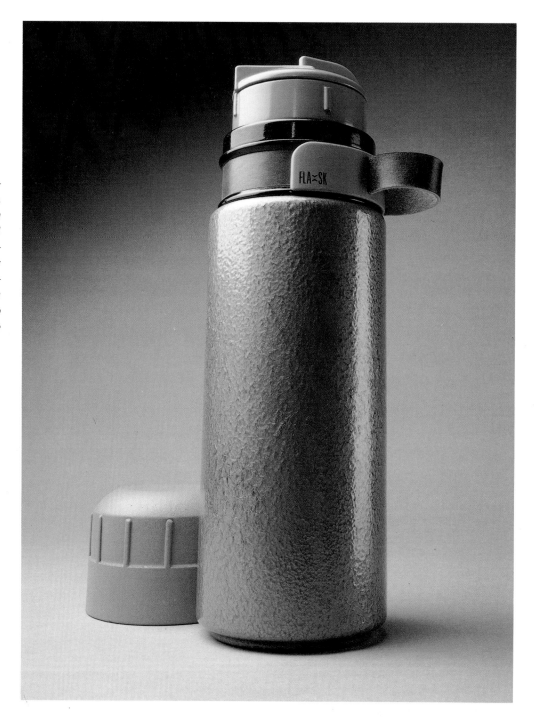

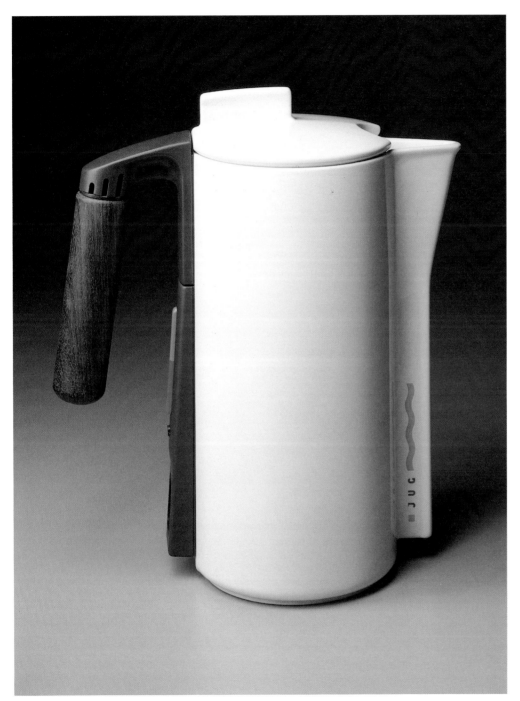

1986 Jug Kettle

The aim of this research project was to see if the ubiquitous (in the UK) plastic jug kettle could be a thing of beauty – a 'ware' rather than a machine. Put another way: why should it have to look more like a toaster than a kettle? The vertical blade below the spout is to grip whilst plugging and unplugging the lead. The handle is wooden for tactility and pleasure but should not be a piece of rain forest. The body is white and the side moulding is dark green.

1983 Enterprise

This was commissioned at the peak of the home computer boom. It was a sophisticated machine with proprietary software, aimed at an 11–14-year-old market. The brief asked for the design of the main machine and a modular system of interconnecting peripherals. We had to engineer the low-cost full-travel keyboard and the peripheral connection system. Our prototype was in shades of pale grey but our client opted for a black-plus-primaries scheme. Manufactured by Enterprise Computers Ltd. Designed with Nick Oakley.

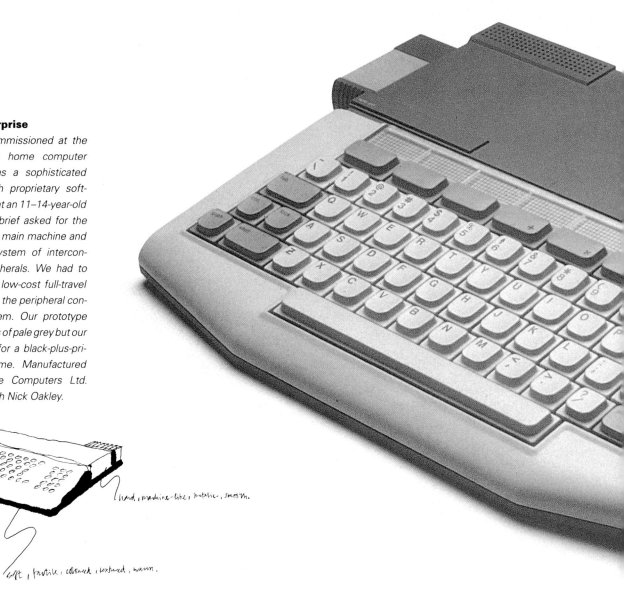

hard, machine-like, metallic, smooth.

soft, tactile, coloured, textured, warm.

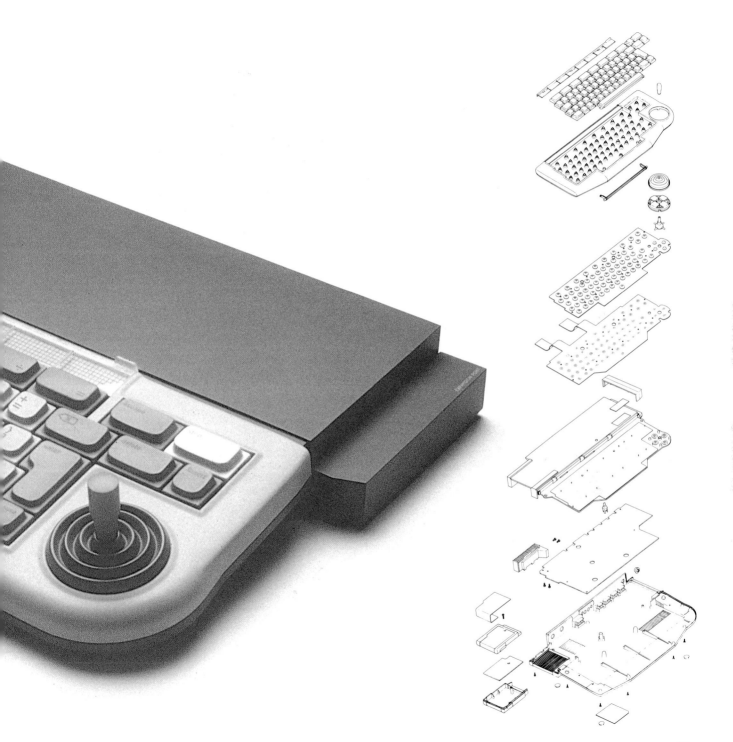

53

1984 Super Enterprise

This large chess-playing computer was to be an intelligent chessboard rather than a big box with chess squares on top. To this end the control panel is treated as an outrigger, seemingly cantilevered from the board, but angled ergonomically towards the player. Colours are shades of purple-grey. Manufactured by White and Allcock Ltd, Hong Kong. Designed with Beverley Andersen.

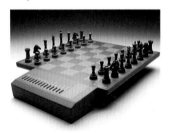

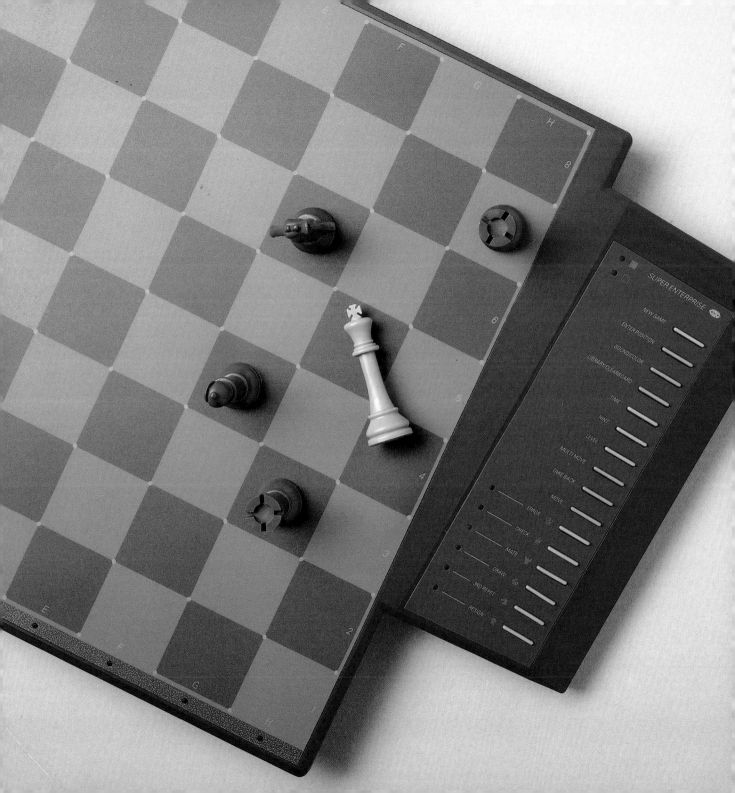

1988 Adversary

A production chess computer called Sphinx was very similar to this prototype, but slightly less interesting. Here the intelligent chess board idea goes further: the board is in traditional black and ivory colours, the display section seems to grow out of it, and the control panel is soft in shape and warm in colour (chestnut) and appears to be clipped on in some way. Made for White and Allcock Ltd, Hong Kong. Designed with Jane Rawson.

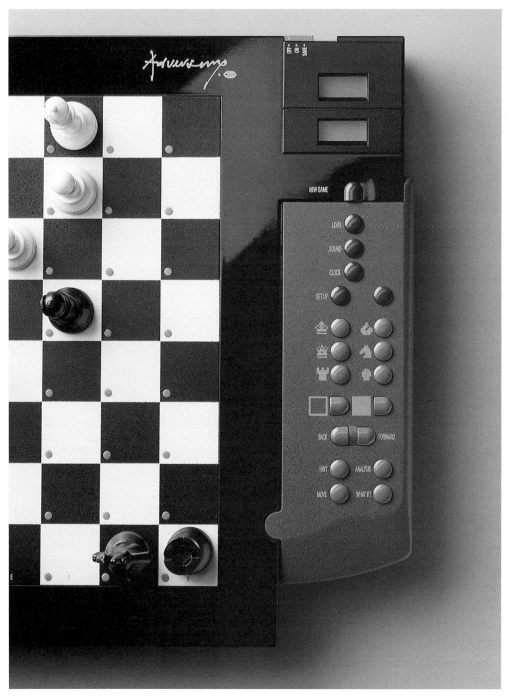

1988 Paperwork Organizer

Filofax had a personal document organizer concept that needed a design and engineering solution. A great deal of design and development went into the loose-leaf binder system which allows individual transparent wallets to be unbound and turned into suspended file pockets. The injection moulded spine assembly is mounted in a leather cover so it had to exhibit high quality and live up to the client's brand indentity. Manufactured by Filofax plc. Designed with John Choong and Martin Riley.

1988 Video Telephone

What should a videophone look like? This is a new kind of product that's still looking for its own form rather than just being a combination of phone and TV monitor. My solution is a vertical structure, adjustable for tilt, which has a handset cantilevered off one side and a display screen cantilevered off the other. The cordless handset is cradled by a soft plastic moulding and the LCD screen is angled slightly towards the user. The colours are not safe: aubergine, olive green, tan and black. The prototype was designed for the Panasonic division of Matsushita Corporation, Japan. Designed with Jane Rawson.

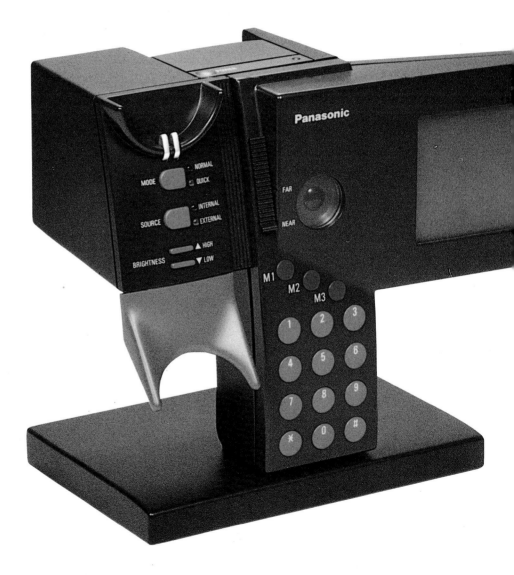

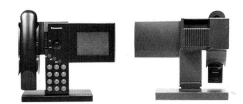

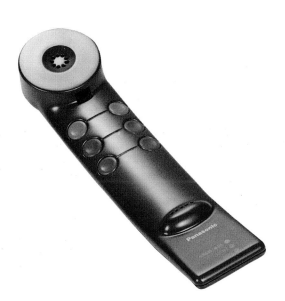

Hollington Associates

Staff and associates from 1980:
Francisco Romero, Beverley
Andersen, Nick Oakley,
John Choong, Leona Simons,
Jane Rawson, Sue Watson,
Simon Morgan, Peter Pfanner,
Leonie Rau, Debra Page,
Stuart Lambert, Martin Riley,
Peter Emrys-Roberts,
Fred Bould, Mandy Elvy,
Paul Sinding, Sushma Patel.

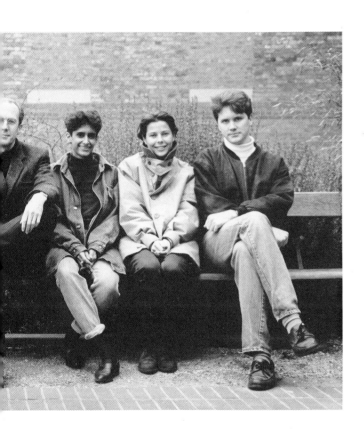

Over There
1984

Back in January 1984 I was invited to Herman Miller's London office to meet 'someone from the US design group'. That someone was Tom Edwards, then Design Manager, now an independent designer with a Herman Miller chair (called 'Capella') of his own. The meeting went well, but it took eight months and several puzzling interviews with senior company people before I gave up waiting for a commission and presented my ideas for a new office chair. This is probably what I was supposed to do.

Within two years I was working on the chairs, some storage cabinets, and a massive office furniture programme, each with its own design manager and development engineering team. It would be another two years before anything could go public, which was very frustrating. However, despite some personal dissatisfaction with the speed at which things progressed, the experience was agreeable. It still is, and programmes seem to run more smoothly now.

I go to the company's Design Yard complex (which looks like an improbably smart but nonetheless hick-styled farm, but houses design, development, prototyping and test laboratory facilities) in Holland, Michigan, every few weeks. I stay at Marigold Lodge, a refurbished lake-side country mansion that serves as a 'learning centre' and provides guest accommodation. The setting is idyllic – ninety degrees in summer and deep snow in winter.

Ralph Caplan, the distinguished writer and historian of Herman Miller's design process (he is also a consultant to the company), was kind enough to write a 'cameo' piece to put things in perspective. It appears on p.76. Herman Miller is justly celebrated for the work it once did with George Nelson, Charles and Ray Eames and others. But if the company is held in high regard it should not just be for its history, it should also be for how it does things now. The process today is different, as Ralph Caplan says: 'That was then, this is now'. In the 1950s D.J. DePree, the company founder, personally managed those famous design projects, and the company was small. Now Herman Miller is huge and design is simply one important part of the corporate agenda. What is remarkable is the way that design and research chief Rob Harvey has constructed a mechanism that can manage design and direct design policy within the corporate behemoth, with utter credibility, whilst somehow keeping the experience personal and the results humane. Design at Herman Miller is strongly managed, yet in my projects with the company I have been given freedom to follow my intuition, take risks and speculate about how things should be.

Individuals called Design Program Managers, or DPMs, deserve considerable credit for making the present system work. DPMs report directly to the most senior management level and each manages a portfolio of projects with outside designers. On each of my projects a DPM is my main link with the company. Though typically design-trained, he or she is not a frustrated designer; just as D.J. DePree did, DPMs listen to and trust the designers they work with. Yes, they can gently steer designs towards some strategic goal but only with the designer's full support. Significantly, in the early stages of a project, marketing people are only involved in a consulting role. Any reactive influence from marketeers is avoided during the formative months of a new product.

I don't have a long-term contract with Herman Miller; our relationship is strictly project-by-project, which suits us both, I believe, as retainers and the like often end in tears.

1988 Support cabinets

These cabinets, with their less than charismatic name, were my third Herman Miller project – but the first to be introduced. The project was a commission, not a speculation. The brief called for a radical storage product to complement Bill Stumpf and Jack Kelley's Ethospace office system, and went some way in defining it: there should be cabinets that structurally connect to the system 'walls' and they should integrate into individual workstations. I proposed a design for a modular family of cabinets with a high degree of usefulness and strong visual character. As a parallel project, Jean Beirise of Cincinnati, Ohio, was commissioned to design a range of interior components. The cabinet is a piece of furniture with a quality of detail and finish not usually found in a system component. Its three alternative heights align with the system's walls. The unexpected shape is the especially narrow cabinet, which is only 460mm wide.

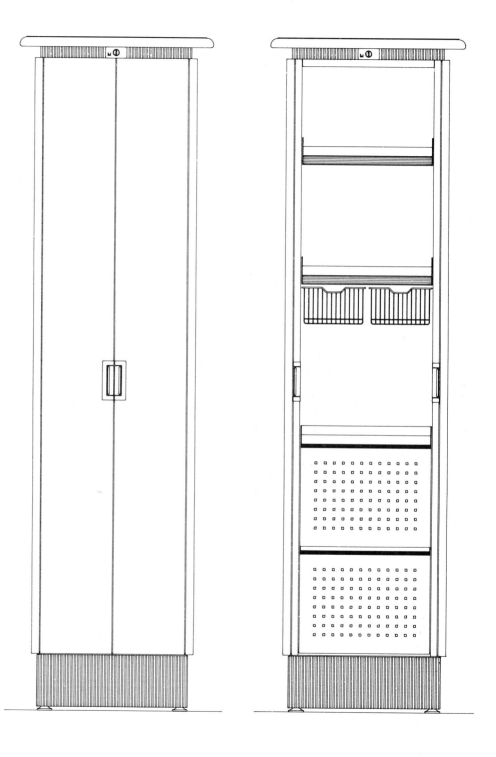

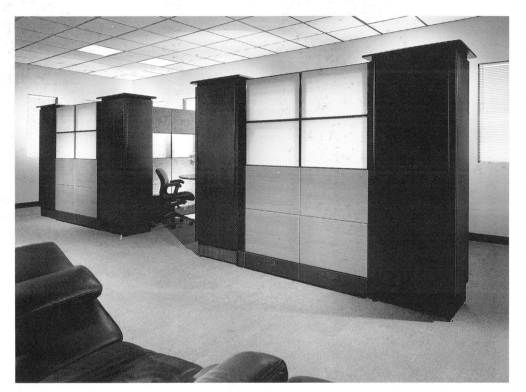

For reasons of cost and structure the cabinets are made mainly from steel. The steel carcass is formed from sheet with a fine dimpled texture and the upper and lower recessed areas are clad with ribbed soft plastic. The client's engineers succeeded in making the pocketing doors run very smoothly by using ball-bearing slides and cables. As the doors hinge and slide away into the carcass the flexible plastic pulls can swivel so their loops are always facing forward towards the user. The taller cabinets, with their over-sailing roof-like tops, have a strong architectural character, which can help to enrich otherwise rather bland system-furnished spaces. They can be used to define entry points or to signal, say, a reception desk. At their lowest height the tops double as 'transaction surfaces' or counters.

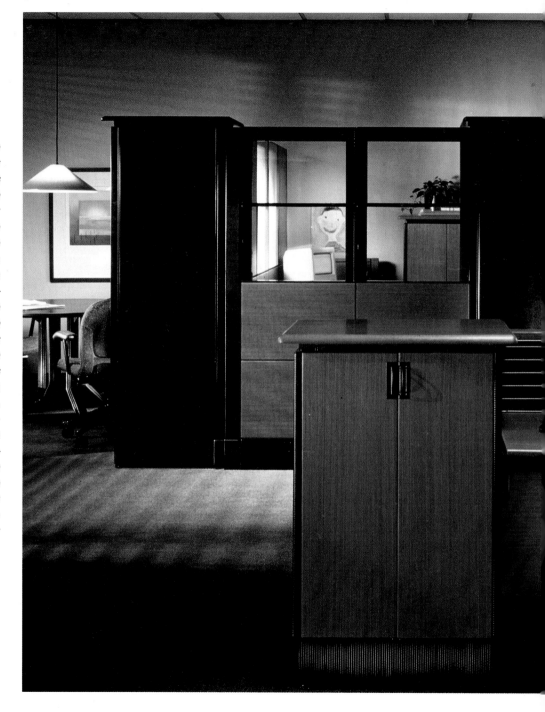

1989 Hollington Chairs

This was the project that got me started with Herman Miller in 1984, but it took nearly five years from start to finish. Not all that time was spent in productive work, as the client chose not to support the project with the development resources that could have brought it to the market more swiftly. Perhaps it was a mistake to code-name the chair 'Flipper', as we did at first, because of its strange armrests. Things improved a bit when we re-named it 'Theo'. The aim was to design a workchair with good comfort and ergonomics that was not macho or technical looking; many office chairs have more in common visually with a photocopier than any kind of furniture. The chair family grew to include a side chair and a lounge chair, and there is now an 'executive' chair too.

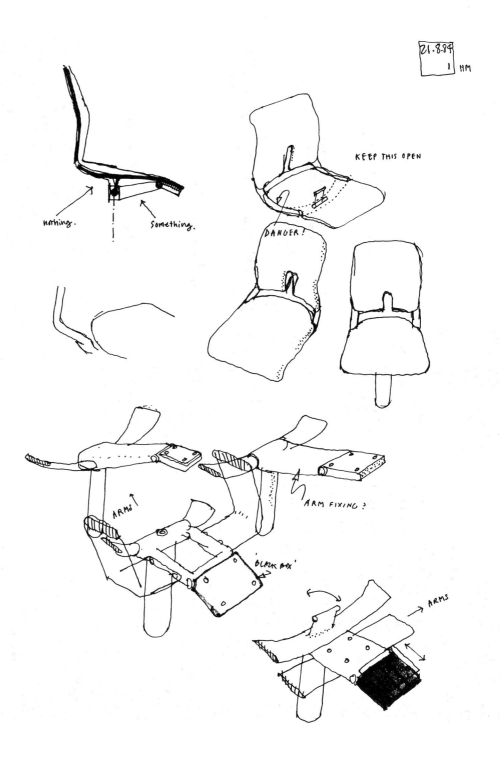

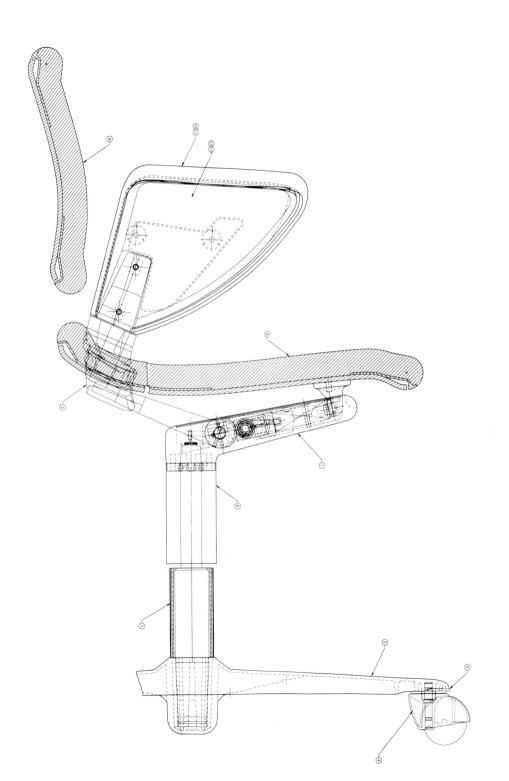

69

The workchair's seat and back shells are hinged together with two strips of flexible glass-plastic composite. Pressure on the back-rest causes it to rotate and pull the seat backwards and down-wards as the seat's motion is con-strained by a horizontal slide. The combined effect is a reclining motion in which the sitter's legs rotate at the ankle, while the knee and hip joints open up. The armrests are designed to sup-port diagonal sitting postures. Reclining movement is con-trolled by a five-spring mec-hanism inside a slim enclosure that 'floats' beneath the seat. All adjustments are made from a control arm that falls to hand directly below the seat edge. The shells are moulded in a glass-filled polyurethane composite.

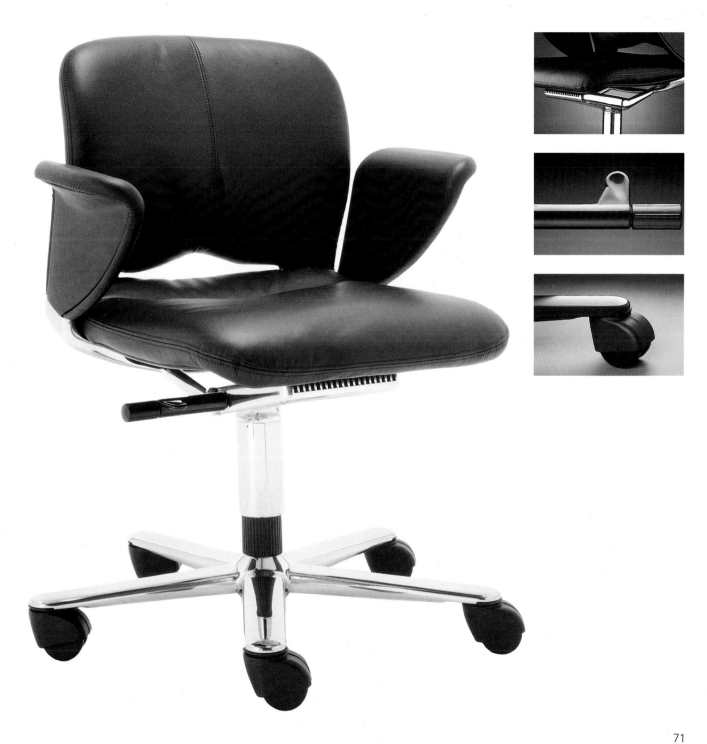

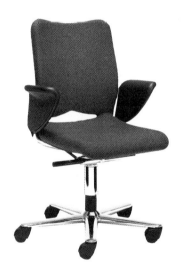

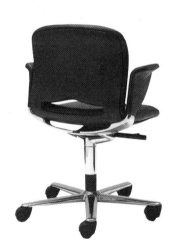

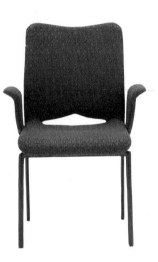

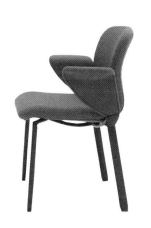
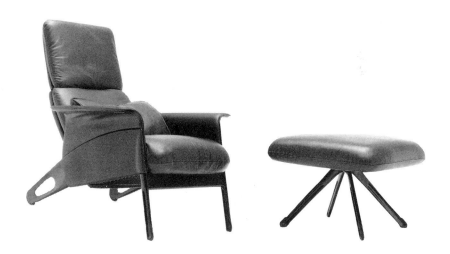

Let's avoid comparisons with Eames' masterpiece lounge chair and ottoman of 1956 – this chair was designed to a very different (self imposed) brief. The backrest angle is adjustable, like a plane seat's, so the chair can be used for informal meetings in offices as well as for reading and contemplation. The backrest is controlled by a pneumatic cylinder that is triggered by a small slider set in the front edge of the right armrest. The loose bolster moves with the backrest but its position can be manually tuned for extra lumbar support. The chair and ottoman are designed to carry just about any kind, colour or design of fabric or leather, as this is a prerequisite of the North American contract furniture business. This was my second design attempt: the first was an inflated version of the workchair and was a disaster.

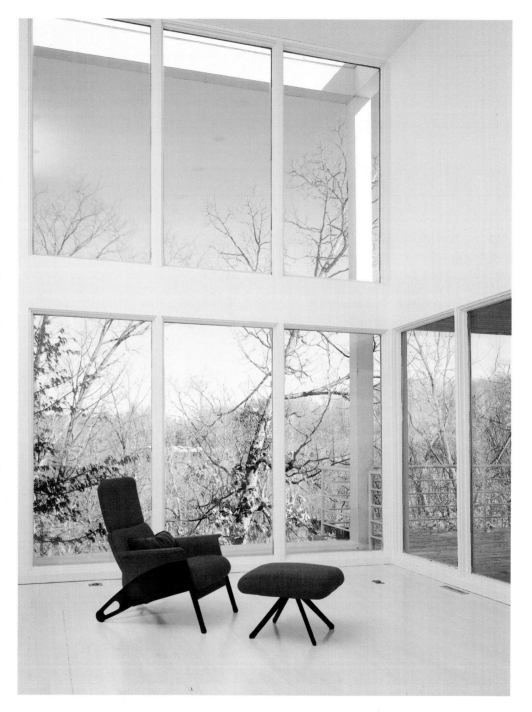

Postlegendary Design
Ralph Caplan

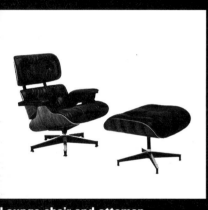

Lounge chair and ottoman, Charles Eames 1956

Table, Isamu Noguchi 1944

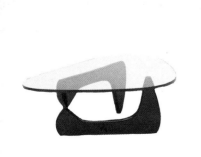

When his Ergon chair was introduced, Bill Stumpf observed wryly that 'designing a chair for Herman Miller is like running for Pope'.

That was then, this is now. Designing a chair, or anything else, for Herman Miller is still not easy, but I doubt that Geoff Hollington hears any Papal overtones. Stumpf was alluding to the scale at which Charles Eames loomed in the corporate consciousness, subjecting any chair that bore the company's name to a barrage of expectations impossible to meet. Stumpf, who has since become legendary himself, was responding to a legend.

The legend was that of a company 'driven', as they say, by design. Gilbert Rohde in the 1930s and George Nelson in the 1940s, set Herman Miller on a course of modern design. Charles and Ray Eames produced stunningly original furniture that helped define the modern aesthetic. Alexander Girard brought colour and texture to the line. But more important than any of their designs was the role that design itself played in the life of the company: according to legend, whatever Charles or George designed, Herman Miller would make.

As legends go, that one wasn't so far removed from reality. Herman Miller did actually take its direction from designers, a process that began 60 years ago with President D.J. DePree, who was a client uncommonly hospitable to ideas. Well, ideas were something the early Herman Miller designers had in abundance, accompanied by a recognition that ideas have consequences and consequences imply responsibility. 'I had a constraint', Charles Eames once told me, 'a feeling that I didn't want to get those nice people in trouble'. In addition to that constraint, and at least as important, the designers had an astuteness that was all the marketing wisdom Herman Miller needed at the time. Listening to them made sense. Having them do the ads and the literature and the showrooms made sense.

Selling what Eames and Nelson had designed brought the company fame and a

certain prosperity. But, in the 1970s, selling what Robert Propst had invented took the company and the industry into a new business: office systems. Propst's Action Office system propelled Herman Miller to a level of growth no one had anticipated. For a while that directional change seemed to encourage a system response to almost every design problem. With the work of such later designers as Stumpf, Don Chadwick, Bruce Burdick and Tom Newhouse, that position softened to acknowledge the legitimacy of privacy in offices and of sensuousness in office *furniture*, a term that Herman Miller had almost stopped using for a while.

Herman Miller still seeks out the creative diversity represented by its renowned designers. But it is not looking in the same places or in the same way, and how could it? What happens when a small, privately owned, west Michigan company transforms itself by design into a large, publicly held international company? For one thing, the design process becomes institutionalized. Today a fairly large design and development operation, housed in a facility called the 'Design Yard', systematically searches out designers and specific projects, then – in collaboration with the designers and other management groups – supervises, nurtures, critiques, and edits them into existence.

Not, on the face of it, the stuff of legends. But Herman Miller is a company that has never put much stock in the face of it, for either legend or reality. Herman Miller has always moved stubbornly below the surface, in depths that made the company hard to understand, even when its products were easy to imitate. No matter how radically the scale, the system and the market have changed; no management structure can substitute for design or for designers, and Herman Miller's management knows that. That is where the newer generation of designers like Geoff Hollington come in. They have to do what designers have always done for companies that have used them well: forge the relationships upon which the force of their own contributions will ultimately depend.

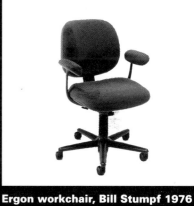

Ergon workchair, Bill Stumpf 1976

Action Office, Robert Propst 1968

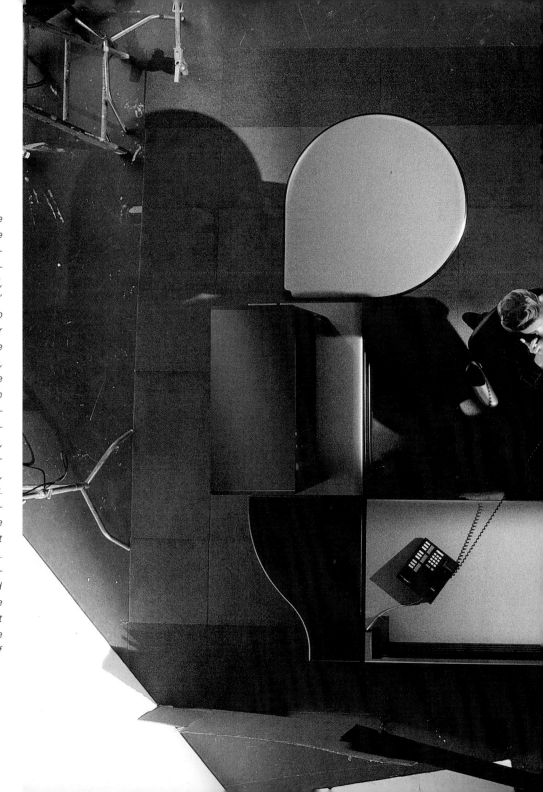

1990 Relay

Relay has turned out to be a huge collection of freestanding office furniture pieces with wide ranging applications, but its beginnings were modest. In 1985, while I was working on 'Theo' (the chairs), I heard that Rob Harvey's group at Herman Miller was becoming interested in the notion of freestanding furniture, as opposed to systems – the company's staple product. With some very rough sketches, I proposed designs for a small collection of tables and storage pieces, sized to drop into Ethospace, Herman Miller's new office system, and help to humanise it a bit. DPM Marsha Edwards was intrigued, but asked for a more comprehensive collection that could build whole workstations. So I tried that, presenting a document now called 'The Big Red Book'. It was a failure, but the second attempt, in a thin booklet called 'Sam II' (Sam was the code name), had all the seeds of today's product.

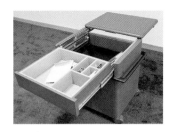

The first Sam prototypes were built in London. It soon became clear that, although the product looked useful, it didn't look right and, furthermore, the vocabulary of pieces was too small to unlock the product's full potential. I decided how the pieces should look. They needed a modern version of the honest, structural wholeness of the best nineteenth century engineering (but without the applied decoration). After all, this was to be real furniture to be kicked around and lived with for decades, not aerospace hardware. This way, I hoped, the 'furniture quality' I sought could be brought to Sam's eclectic mix of materials and processes. The product vocabulary took longer to resolve. It grew to vast proportions, then shrank, then shifted sideways, before project DPM Susan Monroe, product manager Nancy Green and I finally settled on an appropriate mix.

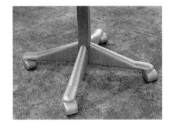

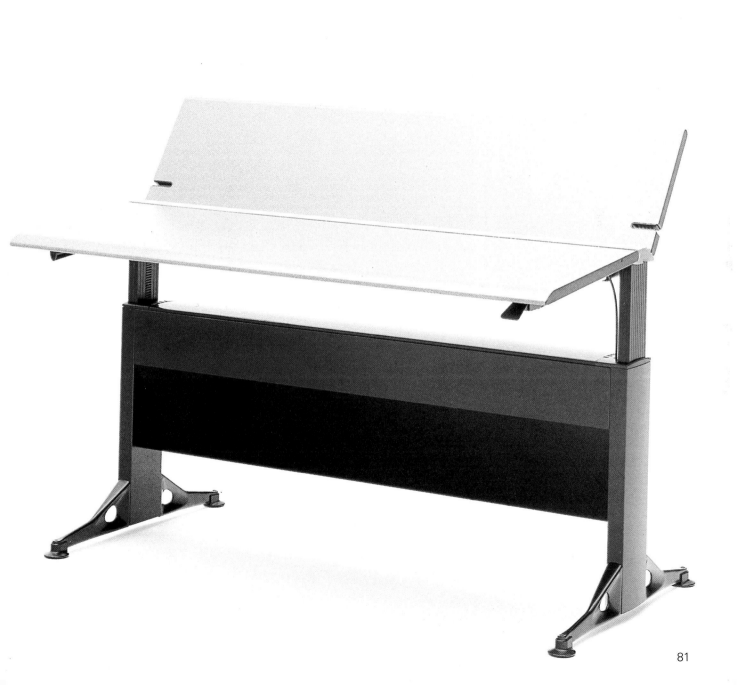

MACHINE SUPPORT

TOOL ZONE

BASE DESK.

OPTIONAL ENCLOSURE

PAPER S.W STORE / HANDLER

LAYOUT TABLE

MODULE WORKPLACE

DISCUSSION TABLE

END SHAPES THAT RELATE VIEW AT RANDOM ANGLES.

TOO SPECIFIC...

TAIL 'BOOKCASE/FILE'

13.1.86 MOM SAM.

29.1.86 2 MOM SAM

→ mobility panel?
→ machinery under table?

→ move stationary proximate storage?
→ privacy screens?
→ move stationary tables?

→ still possible??

don't forget E space connection

machine housing only.

VERY MOBILE FILER...

→ NOT relevant to mobile desk.

Minimum.

golden section ?..?.

1 : 1·68

30"
→ 11·2 + 18·8 = 30
GOLDEN SECTION

| 11·2 | ? |
| 18·8 | |

is depth more economical than width?

CLEAR SPACE

1000
500
1000
500

new desk plan size?

VERTICAL.

SPLIT TOP SO EITHER CAN TILT ALONE.

CANTILEVER EXTENSION

COFFEE PLACE?

THIS ANIMAL?

STANDING HEIGHT.

NATALY WOZNI !!

high performance mobile table DEEP.

continuous work tool zone (either side)

as above with small storage unit under

narrow top mt for computer

standard static table

special ends possible

fixed Reminator meeting table

connection surface

static personal light

mobile w.i.p table adjust ht.

high performance mobile storage

standing height w.i.p desk with storage under fixed height

large Cantilevered Dee end

mobile meeting table.

add on backboard.

Credenza with whiteboard, display, pinboard and bookshelf.

Credenza with tilt display/seat top.

Cantilever top to cover mobile pedestal

top with computer housing under.

clip on hinged sight screen

Partial indirect light

Adjustable personal light

Table height column.

Various storage units with own structure.

	WORKSURFACE
	TOOL ZONE
	STORAGE
	LIGHTING
	VERTICAL PANEL

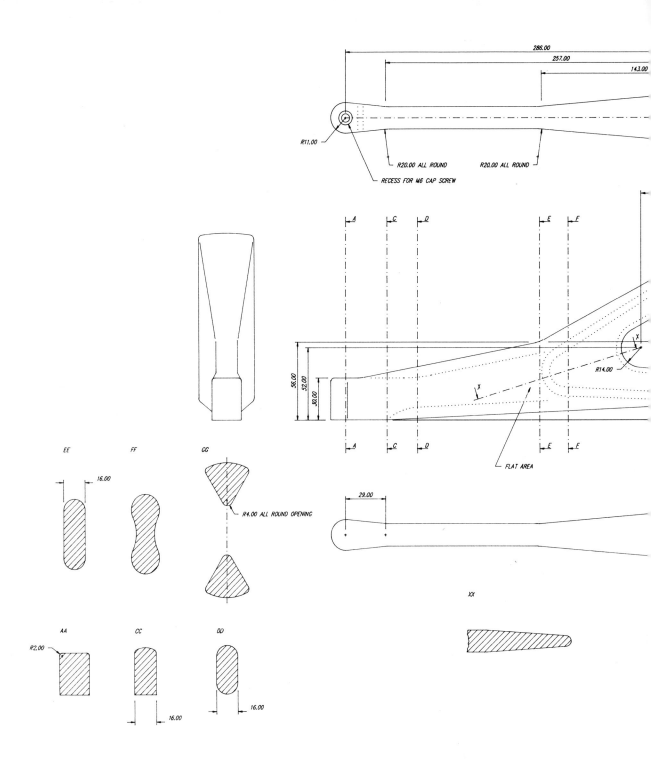

286.00

257.00

143.00

R11.00

RECESS FOR M6 CAP SCREW

R20.00 ALL ROUND

R20.00 ALL ROUND

A C D E F

X

R14.00

56.00

52.00

30.00

X

FLAT AREA

A C D E F

29.00

EE FF GG

16.00

R4.00 ALL ROUND OPENING

XX

AA CC DD

R2.00

16.00

16.00

84

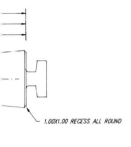

1.00X1.00 RECESS ALL ROUND

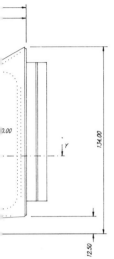

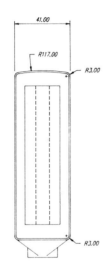

41.00

R117.00

R3.00

134.00

R3.00

12.50

| HOLLINGTON ASSOCIATES LONDON |
| HERMAN MILLER INC ———— SAM |
| SHORT FOOT CASTING PROTOTYPE 3 |
| DATE 1.9.87 SCALE 1:1 DRAWN GH |

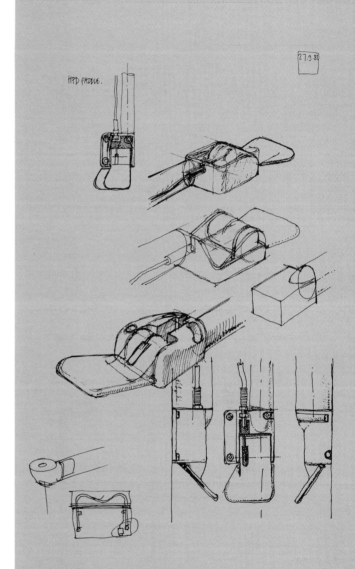

HPD PADDLE.

27.9.88

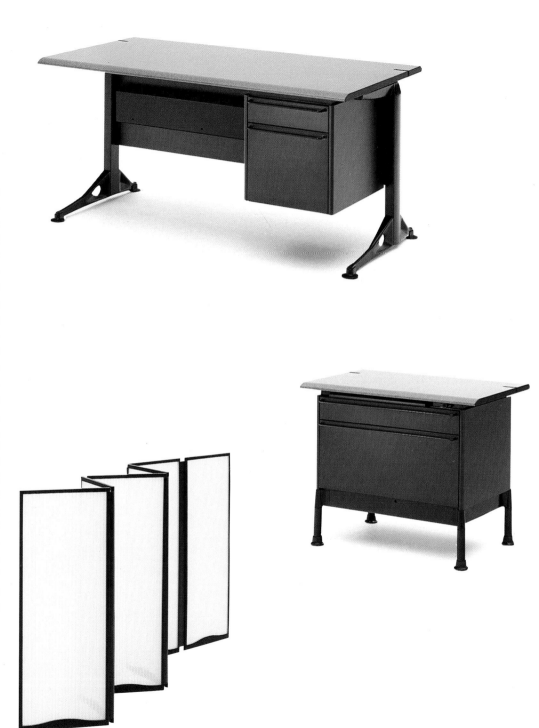

With the Sam II proposal, the design goals had become somewhat paradoxical. The freestanding pieces had to be optimised for workstation-building, but they needed to be as comfortably furniture-like as possible (you could take one home), and they had to be easily movable, so that you could make changes easily, without tools. This meant that some pieces were going to be 'new animals', but they had to be somehow familiar; they would have to knit together into workstations, but still be separate and movable. Added to this, they would need to support computers, wires and cables in a competent but relaxed way. I found that if each piece had a strong individual personality, coupled with simple structural integrity and honest use of materials, it could look and feel like furniture. Then, when 'docked' together into workstations, the diversity of pieces could achieve a surprising unity.

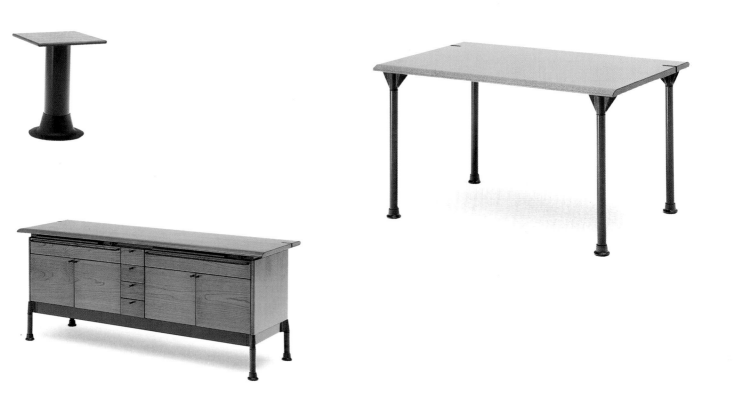

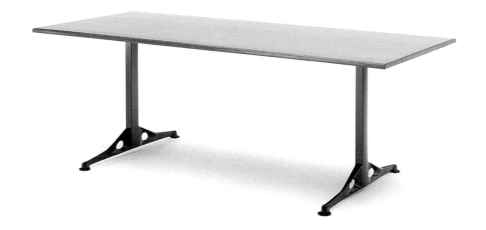

We knew Relay (as it is now known) would work in private offices. Large spaces are more difficult. They need to be 'structured', either by architecture, or by furniture in which case systems furniture is used – it conquers the space. I wanted Relay to conquer space, but the pieces had to dock together, not interconnect. The test of Relay's success was to be its effectiveness in large open offices. People there can experience a lack of identity and personal control; but open offices are good for communication and a sense of community. As organisations de-staff and restructure, these considerations become important. My notion was that with Relay, people would shift furniture to accommodate their work, and they could quickly restructure parts of the office for a special project or for an extra person. Territory would be defined with Relay's taller pieces or Relay would be combined with a panel system.

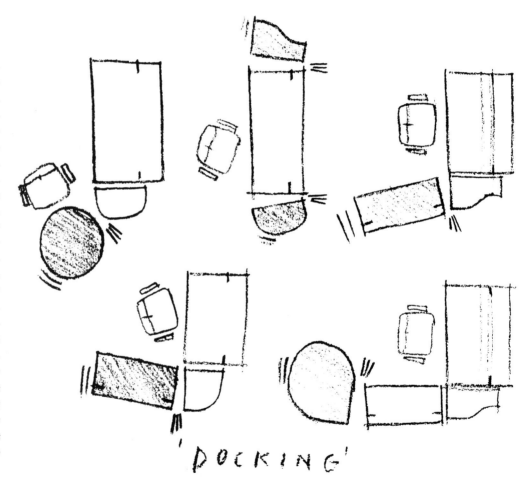

'DOCKING'

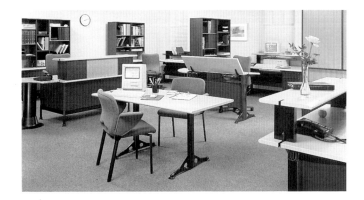

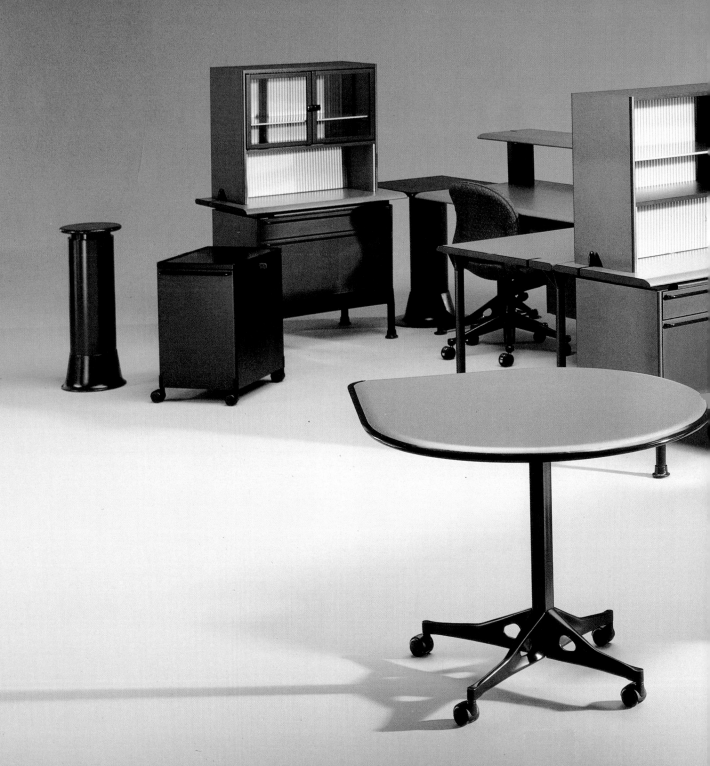

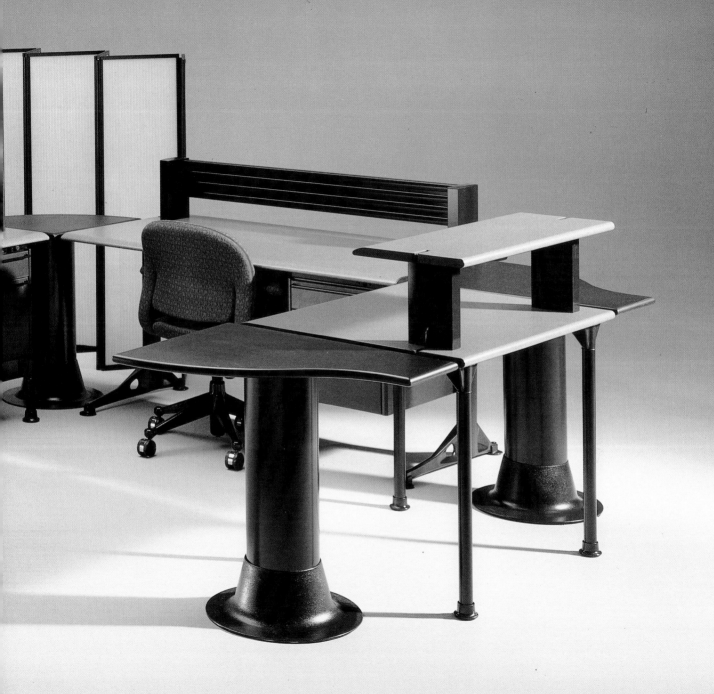

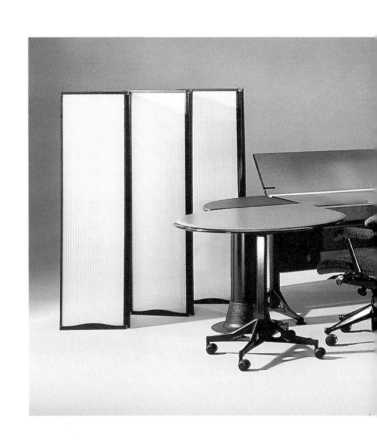

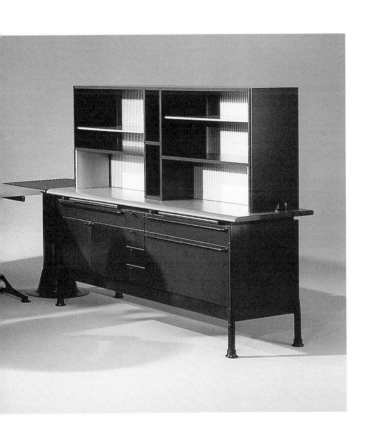

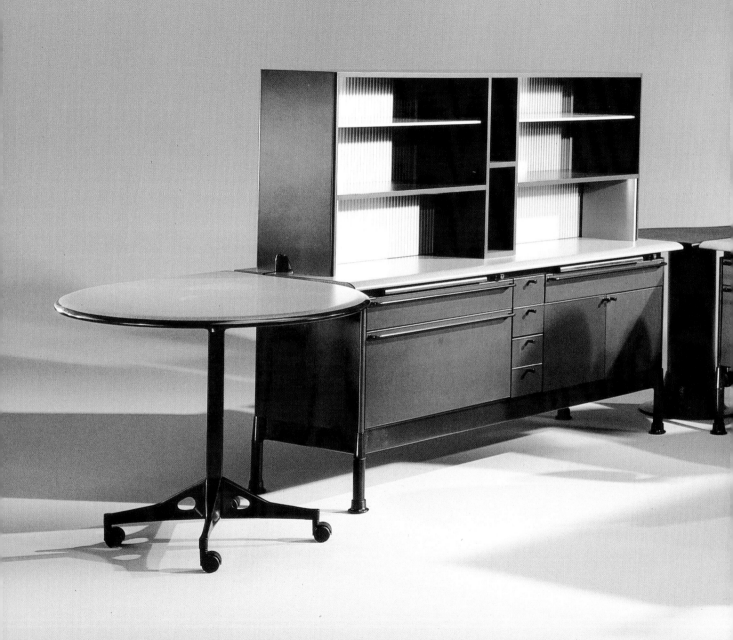

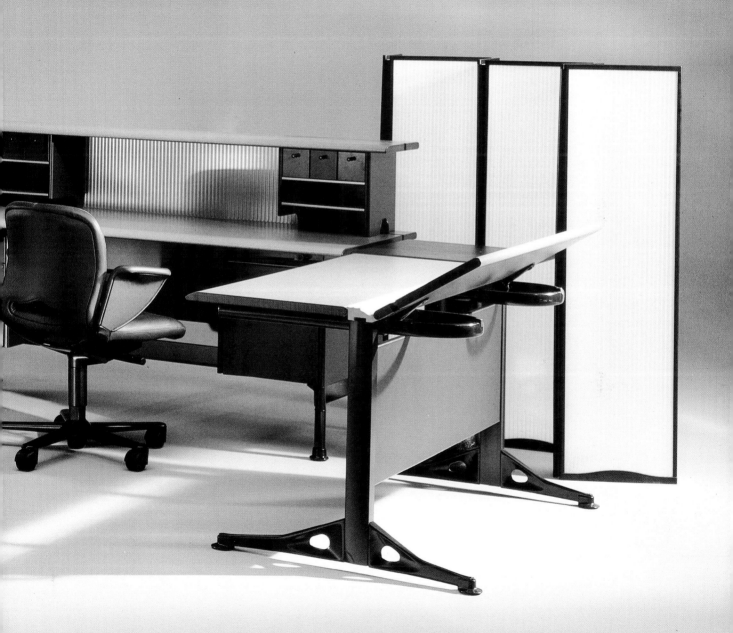

Relay has become a large collection of furniture pieces for manufacture in high volumes. Production economy is important, if pricing is to be competitive, but difficult because of the visual variety and detail. Relay's engineering manager at Herman Miller was Don Goeman. Don's team, working with me, successfully rationalised and value engineered the product – achieving target costs without compromising quality and detail. All the panels and tops are made on an automated line that can turn out wood-veneered or plastic laminate-clad parts. There are many small moulded and cast parts whose precision and finish contribute greatly to the product's quality. The most impressively engineered furniture piece is the High Performance Desk, which can be adjusted from sitting to standing height with one hand. My favourite part is the bone-like cast aluminium foot which, I hope, defies stylistic description.

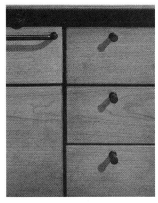

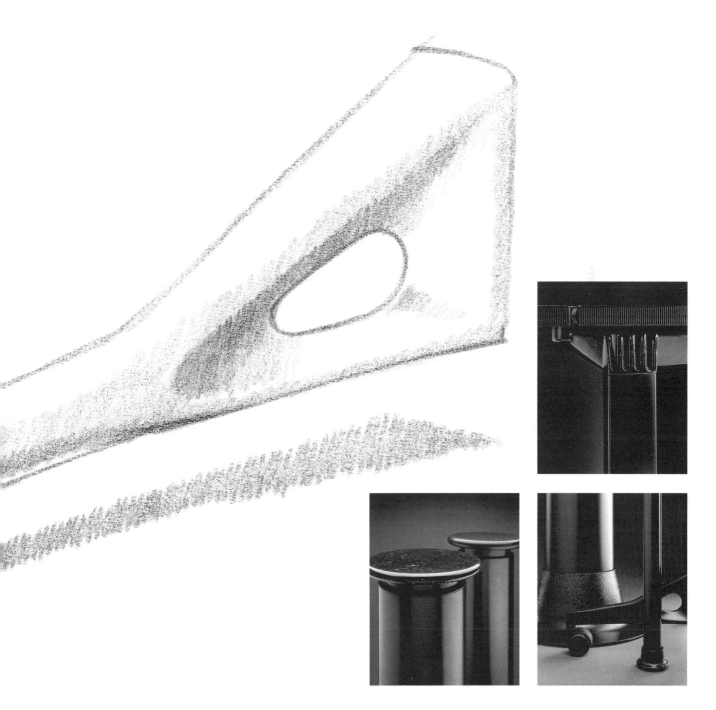

The View from the Plateau
Hugh Aldersey-Williams

Conventional wisdom has it that technological advance proceeds ever faster, that no sooner have we grown accustomed to working and living with one new material or technology than a malicious pack of back-room boffins has devised a new one, more fiendishly complicated than ever before.

A logical consequence of this is to presume that a designer has scant chance to get to master each new advance before it is superseded by the next. There are several things wrong with this view, but it is held nonetheless by many designers who gain comfort in the belief that technology is so complex that they need not bother their pretty heads about it.

One dubious achievement of this view of contemporary industrial design is this paradox: it reinforces the traditional Modernist mindset that it is technology that primarily conditions product form; at the same time it successfully obscures the fact that technology quite simply is not galloping ahead now as it has done at other times. Design does not always run at the heels of technology. Instead, rather like two puppies, design and technology are forever tripping over one another, first one leading, then the other, dragging their human master into the uncertain future.

Geoff Hollington's design is an attempt to acknowledge this interdependence with products and environments that humanize new technologies and new patterns of work and leisure – or re-humanize older ones. The challenge is to do this without resorting to nostalgic styling.

Hollington is unusually competent, knowledgeable and interested when it comes to contemporary technology. This is not to say that he is a technocrat. Far from it. He tries to take a dispassionate view of the role of technology both in his design and in his writing, observing that 'early modern artefacts were generally less sophisticated technically than they looked. Technology didn't catch up with the style (of Modernism) until the 1960s or early 1970s, when industry was finally able to manufacture products

with a realistic interpretation of Modernism's preferences of shape and detail, preferences that relied on mainly imagined manufacturing methods for their original inspiration. Ironically, as soon as this catching up occurred, we started to tire of Modernism's austere formulae and ... all hell broke loose'.

But perhaps it is the other way around. Perhaps we tired of Modernism *because* we had at last mastered the problems of mass-production. For compared with certain periods in the past, the present is a time of comparative stability. Few materials are genuinely new. We are even still encouraged to think of plastics as new, yet most have been around for a decade – or two or three. The capabilities – and limitations – of these and other substances are generally well understood.

The designer on the technological plateau faces three choices.

He or she can stay put. Many designers seem happy to accept that office furniture, fax machines, copiers, computers and such like should look and work a certain way, 'stuck in what we could call "IBM/Xerox modern"'.

There is the chance to explore the plateau. It is relative technological stasis that has permitted the advent of products variously called post-Modern, post-industrial and deconstructionist, as designers, bored with using the 'right' materials, veered off to create glass chairs or concrete stereos.

Finally, there is the distant possibility of moving up off the plateau. This is no mere act of will-power, however. Hollington feels starved of a working knowledge of the technologies that he feels sure lurk behind the doors of the development laboratories of the major – especially Japanese – companies. But there is at least the opportunity, though few designers take it, to think intelligently about future developments and how they can and should influence product form.

Products will have muscles and nerves. They will move, not with the help of moving parts, but at the calling of an electrical impulse. Conversely, the pressure of a human

touch will become an electrical signal just as the human nervous system transforms external sensory input into information for the brain.

The human analogue is compelling, but in some respects products with these attributes will be even more versatile. Once a sensory input (the presence of a finger, a spoken command, a visual image) has been transformed into electrical signals, it is not, as in the human body, stuck in that form. It may be re-converted into sound, light, or movement for output. Products will communicate by gesture, sound and display. They will flex and hum and glow.

The various parts of a product that do these things will gradually intermingle. Even Hollington's study for a personal computer is entirely conventional in its interface. Sharp boundaries delineate the parts you touch, the parts you view and the parts that view you, from their inert surrounds. Future materials with continuously variable properties – hard in one place, rubbery or velvety in another; opaque here, transparent there – will permit these qualities to be blurred.

Hollington foresees an especial dividend in this convergence of the products of manufacture with the products of nature. It may exorcize the architectural formalism that has dominated product design during 200 years of manufacturing history and the best part of a century's existence of the supposedly independent profession of industrial design. Traditional plans and elevations will be inadequate to describe the way these designs blend form and function. Appreciation of the products themselves will be based far less on the platonic geometric sensibility we bring to most of today's 'good design' or indeed on any visual criteria, and more on tactile qualities. Product design will be free of the use of centurys' worth of architectural hand-me-downs as the basis of style; architecture might even pick up ideas from products for a change.

This much may be refreshing, but such a style would not be free of ideological baggage. The closer union of technology and appearance would be greeted with relief

by Modernism's moralists. The technological imperative might once more begin to govern product form. The present may come to appear as merely a brief interlude during which the contents of black boxes (or colourful post-Modern boxes, come to that) bore next to no relation to their tangible, visible surfaces. 'Some styles are programmatic', Hollington suggests. 'They are tied in with the processes of construction and manufacture, whilst others are exclusively applied or superimposed and have no apparent relationship with the process of making. Programmatic styles are believed by many to be *good* and I guess that this idea arose sometime in the late nineteenth century. Superimposed styles by comparison were labelled *bad* or *dishonest* and with many people this idea, this moral dimension, has stuck.'

Hollington is by nature more closely allied with the former school of thought. He welcomes the fact that technology will directly condition the appearance of future designs. 'Because of the cross-linkage of function and structure in such products, it will be harder to be arbitrary with the style. You're back in the land of Eamesian constraints.' Indeed Hollington goes further, suggesting that there is some greater purity in the relation of technology and design to come in the near future than there was in the days of heroic Modernism. 'This new design is revolutionary, because it will be driven directly by technology in a way that the Bauhaus style certainly wasn't (it was driven by the *idea* of technology).'

But the fact that he can distance himself from this somewhat artificial debate between 'stylists' and 'functionalists' indicates that Hollington is no protagonist for either cause. He is ready to move on. On the one hand, Hollington's ethic is often such that he welcomes the close embrace of the constraints of materials, manufacturing processes, and clients' demands. But he also finds inspiration in, for example, Dieter Rams's designs for Braun which demonstrate 'the potential for the relative independence of language, content and expression in product design'.

Although this relative independence may diminish in products using the new interface technologies described, it will not disappear altogether. So while small electronic goods may be conditioned by the subtler presence of new interface technology to achieve more humanized design, other items will use the relative freedom from technological constraint to allow design to address matters of the ritual and context of their usage.

High-tech products have no historical precedent. Criticism centres on their function and it is often taken for granted that they must appear the way they do. Modernism's solution was seen as the only solution. But for a vast range of other products of less specific function, the Modernist approach was only ever an option. And because there was a choice, what began as a fundamental matter of approach was quickly diluted to become simply a question of style.

A Modernist pair of candlesticks, for example, could overlook functional innovation, choosing instead to express the values of Modernism through sculpture. Its main goal would be to put distance between its appearance and that of traditional candlesticks. Hollington's candlesticks are rather different. Their Noguchi-esque lips are rubber, so they flex in order to release solidified wax – a functional advance and a sculptural delight. The other materials – nickel-plated brass and cherry wood – are sufficiently traditional to place these candlesticks with their predecessors.

The two approaches – the technology-led and the archetype-led – should not be seen as contradictory. In something like a personal computer, both will play a role. 'It's very interesting that computer monitors are still designed like televisions, but televisions are almost always backed up against a wall. Computers have to be designed as objects in the round. There's no such thing as perfect appearance. There's only appearance which is appropriate to the job, the task, the context.' So while technology will improve the 'face-to-face' dialogue between man and machine, thoughtful design will consider the product not merely as a platonic object in splendid isolation, what

Hollington criticizes as the 'little symphonies' created by some other designers, but as something that belongs to its context and its environment.

We describe our environments not only in terms of how we use and see them today, but also in terms of appearances and usages in the remembered and received past. Hence, notions of territoriality and domesticity now inform the new generations of products from most leading office furniture manufacturers. In his work for Herman Miller, Hollington is among the leaders in breaking away from the idea that a chair is a machine for sitting in and, through design, linking it back to the familiar forms in the home. His 'Relay' group is a radical extension of that idea to other office furniture.

Acknowledging context in its fullest sense means coming to grips with many other discrepancies of industrial design. Many products still used almost exclusively by women are still designed almost exclusively by men. Office systems are often bought for companies by professional specifiers who may not put the users' concerns uppermost in their minds and who themselves may use different products. Consumer products are designed to conform to an image for sale and not always for easy use.

A Japanese video camera, for example, achieves an enviable integration of its opticals, mechanicals and electronics, so much so that it is currently hard to imagine its being created anywhere but Japan. The corporation's in-house designers use tactile materials and membranes, and are able to do so as a result of the integrated design, development and manufacturing process that their companies sustain. But although these objects are technically brilliant, Hollington finds the interface design decidedly uninspired. 'Not only do you not understand what's inside the black box, but you don't understand how to work the knobs and buttons either. One of those aspects is a problem, the other is not. In fact, I think it's desirable for things to be inscrutable. It makes them more interesting. We have to demystify the interface, but we don't have to demystify the product.'

1990 Candlesticks

The functional constraints on the design of a candlestick are few. A bottle can do the job pretty well. That's why candlesticks have always been a popular vehicle for visual and structural experiment. This design is modest though. The form is bottle-like for stability and as a counterpoint to the slender candle itself. The flange at the top is made from synthetic rubber, so you can easily crack off spilled wax; and its form is amoeba-like to prevent the whole stick-plus-candle having nothing but rotational symmetry. Materials are cherry wood, nickel-plated brass and synthetic rubber. The rubber flange here is coloured a deep purple-blue – one of three interchangeable colours that will come with each candlestick.

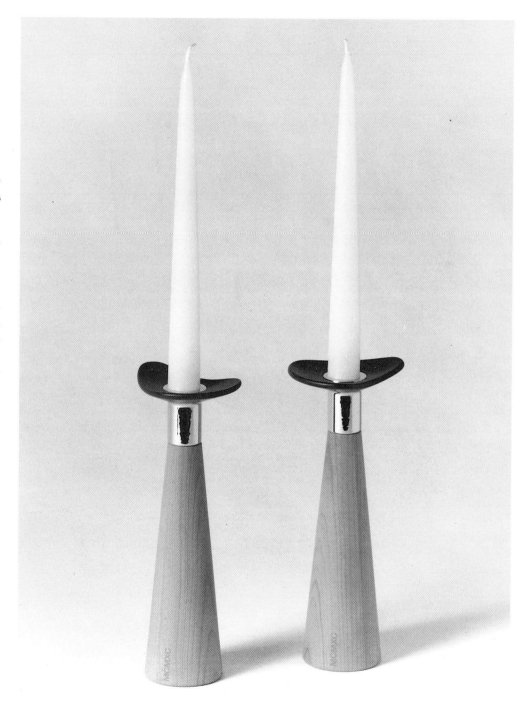

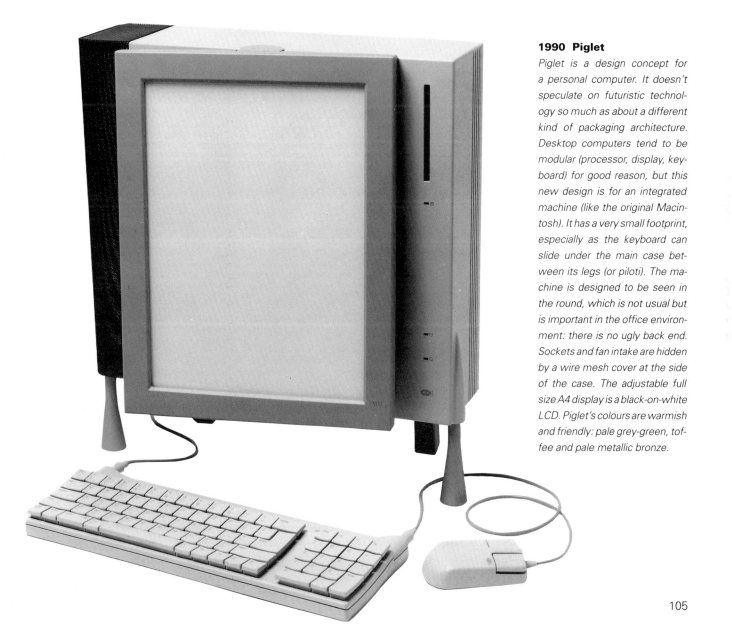

1990 Piglet

Piglet is a design concept for a personal computer. It doesn't speculate on futuristic technology so much as about a different kind of packaging architecture. Desktop computers tend to be modular (processor, display, keyboard) for good reason, but this new design is for an integrated machine (like the original Macintosh). It has a very small footprint, especially as the keyboard can slide under the main case between its legs (or piloti). The machine is designed to be seen in the round, which is not usual but is important in the office environment: there is no ugly back end. Sockets and fan intake are hidden by a wire mesh cover at the side of the case. The adjustable full size A4 display is a black-on-white LCD. Piglet's colours are warmish and friendly: pale grey-green, toffee and pale metallic bronze.

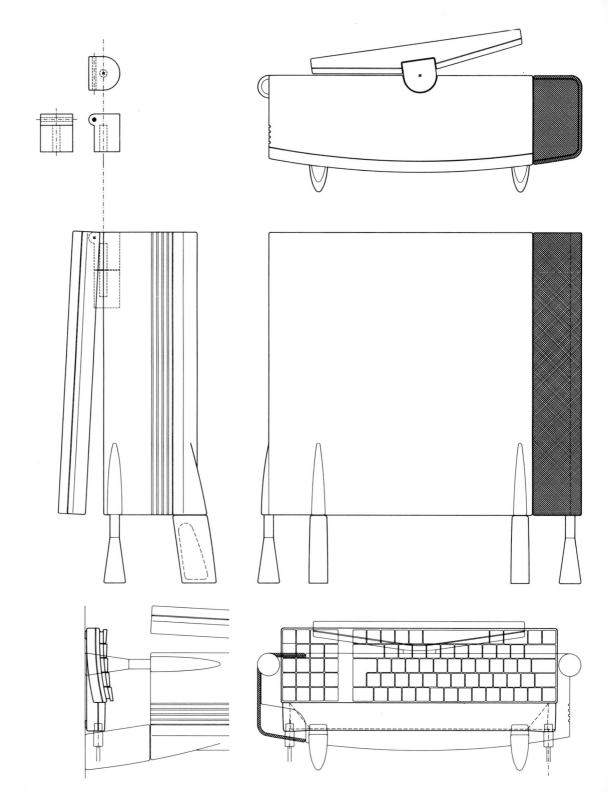

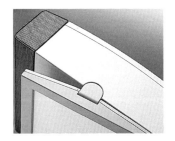

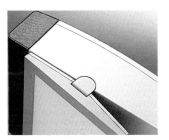

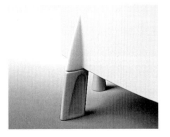

piglet

Project List

1969 Stereo Amplifier.
Prototype.

1969 Exhibition Structure.
Scale model.

1969 Sycamore Chest.
Prototype.

1969 Spiral Staircase.
Scale model.

1970 Room Exhibit.
*Installation, ICA Galleries,
London.*

1971 Tent Structure.
Scale model.

1971–84 Photographs.
Colour slides.

1972 Chair.
*Prototype. Prizewinner,
Dunlopillo Design
Award.*

1973 Azure Court.
Apartment building. Drawings.

1973 Chair Art.
*Two prototype chairs. Designed
with Ben Kelly.*

1973 Fashion Show.
*Installation, RCA. Designed with
Ben Kelly.*

1974 La France.
*Eight photolitho prints. With Ben
Kelly.*

1974 Art Bar.
*Refit of RCA student bar.
Designed with Ben Kelly.*

1974 Fashion Show.
*Installation, RCA. Designed with
Ben Kelly.*

1974 Art Gallery for Milton
Keynes. *Drawings.*

1975 Water Sculpture for
Plymouth. *Competition finalist.
Drawings and scale model.*

1976 'A' Ware, 'B' Ware,
'Y' Ware. *Prototype ceramics.
Designed with Robin Levien and
Ben Kelly.*

1976 Master Aerial.
*Drawings and scale model.
Designed with Michael
Glickman. Consulting engineers
Anthony Hunt Associates.*

1976 Rural Bus Shelter.
*Manufactured for Milton Keynes
Development Corporation.*

1977 Bus Shelter System.
*Manufactured for Milton Keynes
Development Corporation.*

1977 A5 D Roundabout.
*Landscape, Milton Keynes
Development Corporation.*

1977 Street Name Sign System.
*Manufactured for Milton Keynes
Development Corporation.
Designed with Christopher
Woodward.*

1978 Bletchley Bus Station.
*Structure and Landscape, Milton
Keynes Development
Corporation. Designed with Ken
Allinson.*

1978 Shopping Centre Bench.
*Manufactured for Milton Keynes
Development Corporation.*

1979 Plexus.
*Reception and dining furniture.
Manufactured by Pel Ltd.
Designed with Michael
Glickman.*

1979 War Room.
*Office interior, Island
Records Ltd. Designed with
Michael Glickman.*

1979 The Clinic.
*Disc cutting suite, Island
Records Ltd. Designed with
Michael Glickman.*

1980 Infinitum.
*Retail display cabinet system.
Manufactured by Beautiline
Tubex Ltd. Designed with
Michael Glickman.*

1980 Window Display
Structure. *Manufactured for
Vidal Sassoon Ltd.*

1982 George Harvey.
*Office furniture system.
Manufactured by G.A. Harvey Ltd.*

1983 Enterprise.
*Home computer. Manufactured
by Enterprise Computers Ltd.
Designed with Nick Oakley.*

1984 Cheque-Processing
Workstation. *Prototype, IBM UK.
Designed with John Choong and
Beverley Andersen.*

1984 RAT.
Remote computer games controller. Manufactured by Park Electronics Ltd. Designed with Beverley Andersen.

1984 Secta.
Reception seating system. Manufactured by Gordon Russell plc. Designed with Beverley Andersen.

1984 Super Enterprise.
Chess computer. Manufactured by White and Allcock Ltd, Hong Kong. Designed with Beverley Andersen.

1984 Star Chess.
Chess computer. Manufactured by White and Allcock Ltd, Hong Kong.

1985 Alcohol Monitor.
Personal breath tester. Manufactured by White and Allcock Ltd, Hong Kong. Designed with John Choong.

1986 Pocket Chess.
Chess computer. Manufactured by White and Allcock Ltd, Hong Kong.

1986 Jug Kettle.
Prototype.

1986 Camera.
Prototype. Designed with John Choong.

1986 Vacuum Flask.
Prototype. Designed with Jane Rawson.

1986 Telephone.
Prototype. Designed with Simon Morgan.

1986 Coal Burning Appliances.
Drawings, National Coal Board. Designed with Jane Rawson.

1987 Basys.
Office seating. Manufactured by Syba Ltd. Designed with John Choong.

1987 Signature.
Desk system. Manufactured by W.H. Deane Ltd. Designed with John Choong.

1987 Desk System.
Prototype. Designed with John Choong, Peter Pfanner and Peter Emrys-Roberts.

1988 Electronic Diary.
Prototype. Designed with John Choong and Fred Bould.

1988 Support Cabinets.
Office storage system. Manufactured by Herman Miller Inc., USA. Designed with Jean Beirise and Peter Pfanner.

1988 Paperwork Organizer.
Binder system. Manufactured by Filofax plc. Designed with John Choong and Martin Riley.

1988 Adversary.
Prototype chess computer, White and Allcock Ltd, Hong Kong. Designed with Jane Rawson.

1988 Sphinx.
Chess computer. Manufactured by White and Allcock Ltd, Hong Kong. Designed with Peter Pfanner.

1988 Video Telephone.
Prototype, Matsushita Corporation, Japan. Designed with Jane Rawson.

1988 Chess Pieces.
Manufactured by White and Allcock Ltd, Hong Kong. Designed with Jane Rawson.

1989 Stacking Tray.
Veterinary analysis slides-storage. Manufactured by VetTest UK Ltd. Designed with Martin Riley.

1989 Hollington Chairs.
Office seating. Manufactured by Herman Miller Inc., USA.

1990 Relay.
Office furniture group. Manufactured by Herman Miller Inc., USA.

1990 Prefabricated Strong Room System. *Manufactured by John Tann Ltd. Designed with John Choong and Paul Sinding.*

1990 Piglet.
Prototype computer.

1990 Candlesticks.
Prototypes.

Bibliography

Books

Ca Y est, January 1988 (catalogue, Japan).

Histoire du Design, Jocelyn de Noblet, Somogy, 1988 (France).

Masters of European Design, Ediciones Atrium, 1988 (Spain).

New British Design, John Thackara, Thames & Hudson, 1987.

The New Furniture, Peter Dormer, Thames & Hudson, 1987.

Product Design 3, Joe Dolce, PBC International Inc., 1988.

Street Style, Catherine McDermott, Design Council, 1987.

Journals

The American Design Adventure (Arthur J. Pulos), *Designers Journal*, Geoff Hollington, March 1989 (book review).

Avant Premier, *Blueprint*, Geoff Hollington, July 1989 (exhibition review).

A Ware, *Design*, February 1977.

British Design (Frederique Huygen), *Designer's Journal*, Geoff Hollington, June 1989 (book review).

The Chair That Came in From the Cold, *Blueprint*, June 1989.

Debunking the Boss's Chair, *Design*, June 1987.

Design Works, Hollington Associates, *Axis*, January 1990 (Japan).

Eames Design (John and Marilyn Neuhart), *Blueprint*, Geoff Hollington, November 1989 (book review).

Enterprise Out of the Ordinary, *Design*, November 1983.

The Furniture Oligarchy: MFI, *Design*, Geoff Hollington, May 1988.

Geoff Hollington, *Designer*, March 1986 (interview).

Hollington Associates, *Brutus*, May 1987 (Japan, interview).

Hollington Associates 82–86, *Domus*, November 1987 (Italy).

Hollington Associates, *Fusion Planning*, November 1987 (Japan).

Hot Design and Hot Style, *Fusion Planning*, January 1989 (Japan).

In Braun Country, *The Design History Society Newsletter*, Geoff Hollington, October 1980.

The Last Word on Product Identity, *Design*, Geoff Hollington, February 1980.

Master's Choice, *ID*, September 1987 (USA).

The Material of Invention (Ezio Manzini), *Designers Journal*, Geoff Hollington, June 1987 (book review).

Modern Movement: There's Life in the Old Girl Yet, *Design*, Geoff Hollington, February 1979.

My First Job, *The Designer*, Geoff Hollington, September 1983 (interview).

Nine to Five and After, *Blueprint*, Geoff Hollington, April 1987.

Office Furniture (Lance Knobel), *Design Week*, Geoff Hollington, 18 September 1987 (book review).

Douglas Scott (Jonathan Glancy), *Blueprint*, Geoff Hollington, July 1988 (book review).

Tools of the Trade, *Building Design*, Geoff Hollington, December 1985.

Two Screen Tests, *Design Week*, 24 October 1986.

Acknowledgements

Photograph Credits

Unless otherwise noted, all photographs, sketches and drawings in this book © Geoff Hollington. Credits for all other photographs appear below.

Stephen Bicknell: 28–9
Piers Bizony: 104–5, 106–7
Martin Chaffer: 20
John Donat: 34–5
Michael Freeman: 30
Herman Miller Inc.: 65, 66–7, 70–1, 72–3, 74–5, 76–97
Matsushita Corporation: 58
Steven Oliver: 52
Dick Painter: 42–3
Terence Reading: 39
Patrick Shanahan: 38
Carol Sharpe: 41, 46–7, 54–5, 56–7
Frank Thurston: 24–5, 31
Adam Tolner: 40, 48–9, 50–1

Special Thanks

We would like to thank Rob Harvey, Susan Monroe and Don Goeman of Herman Miller Inc.; Mark Brutton, Michael Glickman, Tom Edwards, Ben Kelly and Robin Levien for agreeing to be interviewed; and Nancy Green and John Berry of Herman Miller Inc. for their support.

We are also grateful to the following individuals and organizations for support with material: Waltraud Beckman and Richard Rutledge of Herman Miller Inc., *Design Magazine*, Filofax plc, General Motors Corporation, Gordon Russell plc, IBM Europe, Matsushita Corporation, Milton Keynes Development Corporation, Pel Ltd, Syba Tek Ltd, White and Allcock Ltd. Thanks to Forum for so much creative model-making; and to Jane Rawson, Mandy Elvy and Fred Bould at Hollington Associates.

For Liz
GH